IMAGES
of America

NEW ORLEANS
CEMETERIES

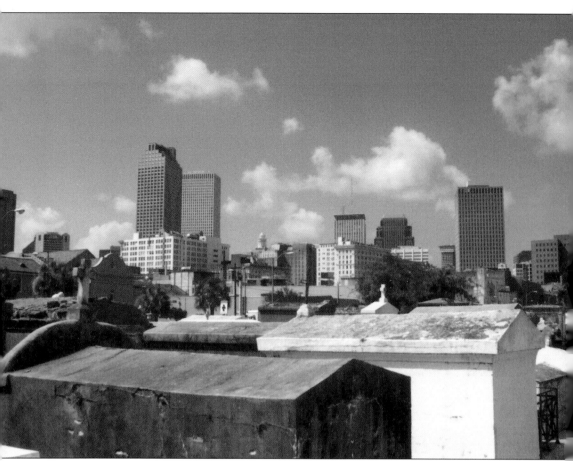

The skyline of modern New Orleans rises above the ancient tombs of St. Louis Cemetery I, established in 1789. St. Louis I is the oldest cemetery in New Orleans, though not the first. New Orleans itself was founded by Jean Baptiste le Moyne, Sieur de Bienville (1680–1768) in 1718. Though his name is intimately associated with the Crescent City, Bienville is not buried here but in Montmartre Cemetery in Paris, France.

IMAGES
of America

NEW ORLEANS
CEMETERIES

Eric J. Brock

ARCADIA
PUBLISHING

Published by Arcadia Publishing
Charleston, South Carolina

Printed in the United States of America

Library of Congress Catalog Card Number: 99-60803

For all general information contact Arcadia Publishing at:
Telephone 843-853-2070
Fax 843-853-0044
E-Mail sales@arcadiapublishing.com
For customer service and orders:
Toll-Free 1-888-313-2665

Visit us on the Internet at www.arcadiapublishing.com

CONTENTS

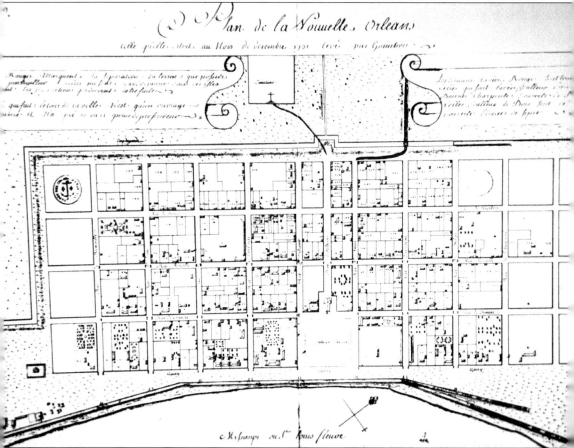

New Orleans' first burials took place along the riverbank. In 1721 Royal Military Engineer Adrian DePauger laid out the town of Nouvelle Orleans, essentially today's French Quarter. A new cemetery was placed just north of the town's limits (the square at top of this 1731 map, just left of center). Today that site is on St. Peter Street, between Burgundy and Rampart Streets and extending half a block back toward Toulouse Street. There is today no visible evidence that this location was once a cemetery, though a 1984 archaeological study of the site revealed much about life and death in colonial New Orleans. The St. Peter Street Cemetery was used exclusively from 1721 to 1789, when St. Louis I was consecrated. In 1800 the St. Peter Street Cemetery was closed, and its site was subdivided and sold as building lots in 1801.

INTRODUCTION

The cemeteries of New Orleans have been a subject of interest and even fascination for visitors and residents alike for more than two centuries. In the historic burial grounds of the Crescent City there is much history, much beauty, much mystery.

New Orleans' cemeteries are primarily, though not exclusively, built above ground, which is to say that "burials," or more properly, interments, take place in vaults built above ground level. The prevailing myth is that this is done because New Orleans is largely situated at or below sea level and that the ground's high water table makes it virtually impossible to bury in the soil.

In truth, however, the tradition of above ground interments is more cultural than practical (though certainly the practicality of the method in New Orleans' particular environment played a role in its adoption). Above ground interment is common throughout the Latin world and, indeed, is more the rule there than the exception. Throughout Latin America and Mediterranean Europe, even in high and hilly places, above ground interment is the norm. New Orleans is essentially a Latin city, founded by the French and long ruled by France and Spain alike. It is only natural that the burial customs prevailing in the mother countries and in the fellow colonies of those countries should also prevail in New Orleans.

In the United States, however, above-ground interment is the exception rather than the rule—except in New Orleans and the surrounding country of south Louisiana. Elsewhere in the nation above-ground tombs are the domain of the rich, and only of a minority of them. Most burials take place in the earth; in New Orleans it is the opposite.

In-ground burials have long taken place in New Orleans, however. The city's first burials along the riverbanks were in the earth, as were the majority of burials in the first formal cemetery on St. Peter Street. There is considerable evidence, also, that many early burials in St. Louis Cemetery I, today the city's oldest remaining cemetery, took place in the ground as well. Indeed, the majority of the interments in the Protestant section of St. Louis I are in-ground burials. This makes perfect sense since the city's early Protestants were primarily from cultures that did not usually employ above-ground tombs while the Catholic majority hailed from cultures that did. As time went by, however, the Protestants, too, adopted the prevailing local tradition of above-ground interments.

The city's sizeable Jewish population never adopted the concept of above-ground interments, and New Orleans' several Jewish cemeteries, from those established in the early 19th century to the very newest, all contain only in-ground burials. Newer cemeteries of all faiths also contain fewer above-ground tombs than in decades past; the main reason is expense, for tombs are very costly. In many historic cemeteries the newer sections often consist of multi-level mausoleums in which crypts may be purchased for a fraction of the cost of building family tombs. Indeed, in modern New Orleans, family tombs, as elsewhere in the nation, are becoming more and more the domain of the rich and thus, unfortunately, fewer and fewer are being built.

In the city's earliest cemeteries, above-ground tombs were expensive and thus often not built. New Orleans has no natural stone nearby, and bricks were better used in constructing dwellings for the living. Fortunately so, for archaeological investigations, such as the study of the site of the former burial ground in St. Peter Street in the spring of 1984, revealed much about the citizens of early French New Orleans. Indeed, the early citizens themselves told their stories through their remains. In a small portion of the cemetery site 32 burials were exhumed and studied by archaeologists and forensic anthropologists from Louisiana State University in Baton Rouge, and a wealth of data was revealed. It is interesting to note that in about 1794 the walls of the St. Peter Street Cemetery were demolished and their bricks used in the construction of the church of St. Louis (now the cathedral) in its reconstruction by prominent citizen Don Andres Almonester y Roxas (1724–1798). Thus elements of this first city of the dead are incorporated into one of the most visible and significant landmarks of the surrounding city of the living.

There are, of course, many cemeteries in metropolitan New Orleans, old and new, but the focus of this book is on the historic burial grounds, the oldest and arguably most important cemeteries of the city. Certainly they are the most important in terms of the city's heritage and of its tourism. A caveat to tourists, however, is a fact already well known by residents—be careful when visiting the cemeteries. The same above-ground tombs that shelter the dead of ages past can also conceal the living, and the same quiet solitude that makes the cemeteries havens from the bustling city surrounding them can also isolate the casual visitor.

Save Our Cemeteries, a nonprofit advocacy group working for the preservation and protection of New Orleans' cemeteries, can provide information on tours, cemetery hours, and other general information for visitors; their work in preserving the historic burial grounds of New Orleans is invaluable. Save Our Cemeteries is listed in the telephone directory as are the offices of several (though not most) of New Orleans' cemeteries.

—Eric J. Brock

One

ST. LOUIS CEMETERY NUMBER I

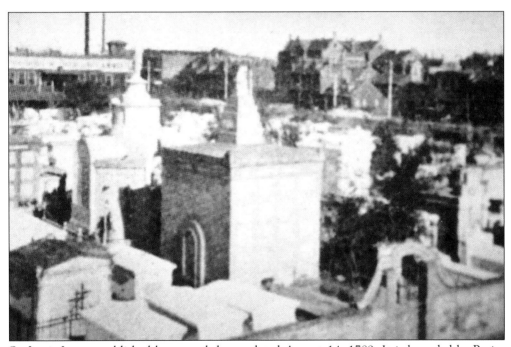

St. Louis I was established by a royal decree dated August 14, 1789. It is bounded by Basin, Conti, Treme, and St. Louis Streets, though it originally covered a much larger area, extending nearly to Rampart Street. St. Louis I is today the oldest extant cemetery in New Orleans and contains the remains of many notable citizens, including Confederate Generals Albert Gallatin Blanchard (1810–1891) and John Breckenridge Grayson (1806–1861); Myra Clark Gaines (1803–1885), whose fight to gain her father's estate led to the longest running lawsuit in American history; Homer Plessy (1862–1925), plaintiff in the landmark Supreme Court case *Plessy v. Ferguson* (1896), which established the doctrine of "separate but equal"; land developer Bernard de Marigny (1788–1871); and Mayor Ernest "Dutch" Morial (1929–1989). The image above, though not crisp, is a valuable one as it shows the cemetery viewed from above Conti Street looking toward Basin Street in the 1890s.

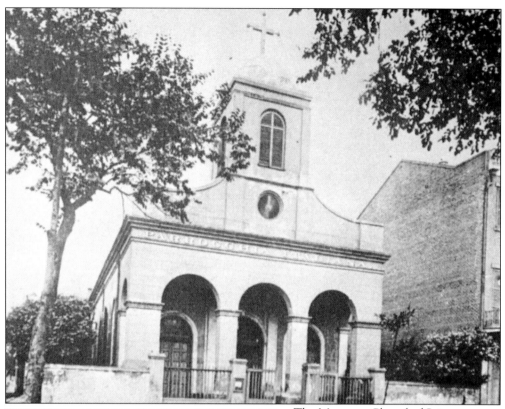

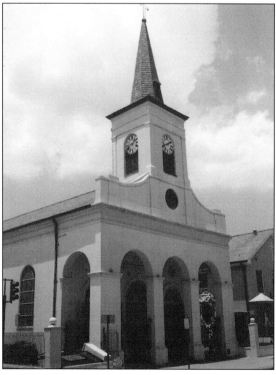

The Mortuary Chapel of Saint Anthony, located on Rampart Street near what was then the lower edge of St. Louis I, was built in 1827 after it was forbidden to hold funerals in St. Louis Cathedral for fear of contagion. Designed by the firm of Gurlie and Guillot, architects and builders, it is now the Church of Our Lady of Guadalupe. The top photograph shows the chapel as it appeared about 1885; the bottom photo is of the structure today.

The oldest marked tomb in the cemetery bears an iron cross of the sort once frequently found in New Orleans (and still common in early rural south and central Louisiana cemeteries). It marks the grave of Antoine Bonabel, who died February 5, 1800. Earlier graves are known to exist here but none are marked with their dates of death. As recently as the 1930s, however, a number of tomb tablets still bore death dates from the 18th century.

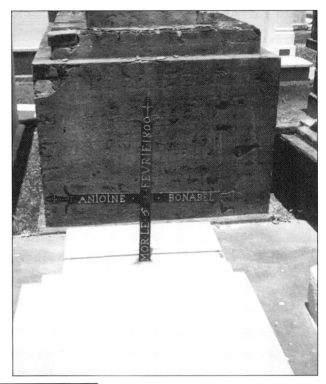

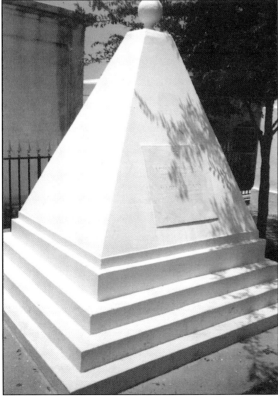

The pyramidal Varney family tomb, near the main entrance gate, marks the original geographic center of St. Louis I. One of the oldest surviving tombs in the cemetery, it probably dates from the first decade of the 19th century.

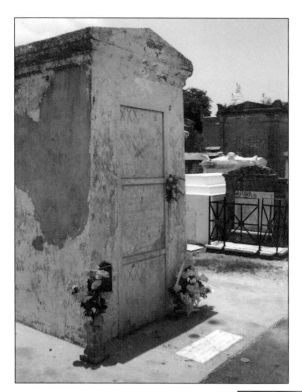

Perhaps the most famous tomb at St. Louis I is that believed to hold the remains of Marie Laveau, the "Voodoo Queen," who died in 1881. It is not known if Marie actually occupies this tomb, but in the 1960s a "tradition" of making "X" or cross marks on the tomb began for no known reason (other than, it would appear, encouragement by misguided tour guides). The result is tantamount to vandalism and has done extensive damage to this and nearby tombs. The practice of making such markings, incidentally, has no basis in voodoo ritual or tradition.

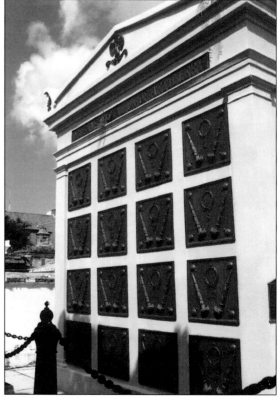

The grandiose New Orleans Battalion of Artillery tomb was designed by noted architect Jacques N.B. de Pouilly and is unusual in that its vault slabs are of cast iron, rather than the usual marble. Each bears inverted torches, symbols of death, coupled with a laurel wreath, symbolizing honor. On the pediment is a winged hourglass, symbolic of life's brevity. The surrounding fence is of chain strung between mock cannon barrels with cannonball finials.

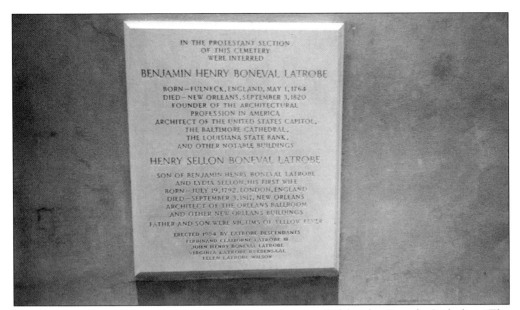

IN THE PROTESTANT SECTION
OF THIS CEMETERY
WERE INTERRED

BENJAMIN HENRY BONEVAL LATROBE

BORN – FULNECK, ENGLAND, MAY 1, 1764
DIED – NEW ORLEANS, SEPTEMBER 3, 1820
FOUNDER OF THE ARCHITECTURAL
PROFESSION IN AMERICA
ARCHITECT OF THE UNITED STATES CAPITOL,
THE BALTIMORE CATHEDRAL,
THE LOUISIANA STATE BANK,
AND OTHER NOTABLE BUILDINGS

HENRY SELLON BONEVAL LATROBE

SON OF BENJAMIN HENRY BONEVAL LATROBE
AND LYDIA SELLON, HIS FIRST WIFE
BORN – JULY 19, 1792, LONDON, ENGLAND
DIED – SEPTEMBER 3, 1817, NEW ORLEANS
ARCHITECT OF THE ORLEANS BALLROOM
AND OTHER NEW ORLEANS BUILDINGS
FATHER AND SON WERE VICTIMS OF YELLOW FEVER

ERECTED 1984 BY LATROBE DESCENDANTS
FERDINAND CLAIBORNE LATROBE III
JOHN HENRY BONEVAL LATROBE
VIRGINIA LATROBE RUEDENSAAL
ELLEN LATROBE WILSON

The Protestant section was set aside in 1805 and was called by the French Catholics "The Cemetery of Heretics." Here the city's Protestants and few Jews also were buried in the early days of the American period. One of the most prominent persons buried here is architect Benjamin H.B. Latrobe (1764–1820), designer of the U.S. Capitol Building in Washington, D.C.

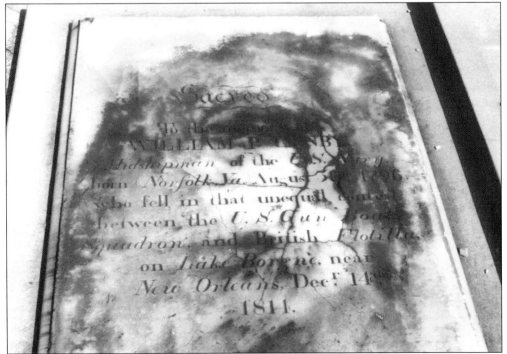

Numerous casualties of the War of 1812's Battle of New Orleans are buried here also, such as William P. Canby (1796–1814), midshipman on the U.S. gunboat *Squadron*, which fought the H.M.S. *Flotilla* on Lake Borgne.

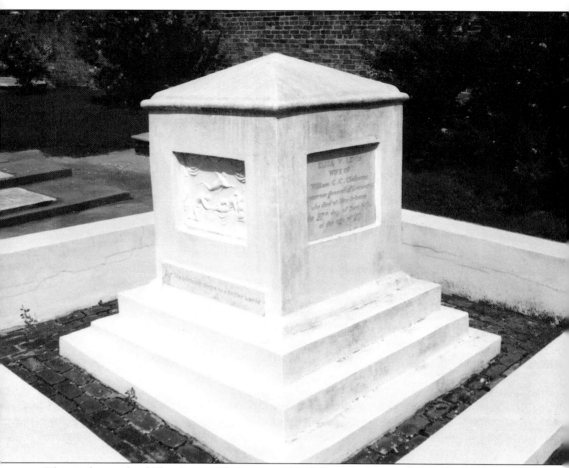

This is the tomb of Eliza Lewis Claiborne, wife of the first American governor of Louisiana, William Charles Cole Claiborne, and their daughter Cornelia. Mother and daughter died of yellow fever on the same day; Mrs. Claiborne was 27. The tomb was designed by architect Benjamin Latrobe and built by sculptor Franzoni in Philadelphia in 1811. Nearby is the tomb of the second Mrs. Claiborne, Clarisse Duralde, who died at 21. Claiborne himself rests at Metairie Cemetery.

An early 19th-century marble monument, originally standing upright over an in-ground burial, is now set horizontally in concrete. The epitaph speaks for itself.

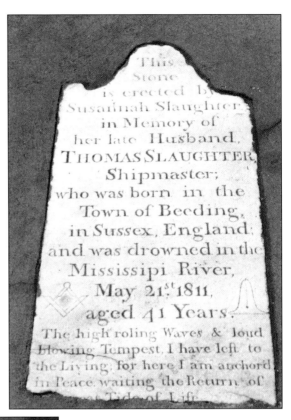

This Stone is erected by Susannah Slaughter, in Memory of her late Husband, THOMAS SLAUGHTER, Shipmaster; who was born in the Town of Beeding, in Sussex, England; and was drowned in the Mississipi River, May 21st 1811, aged 41 Years. The high roling Waves & loud blowing Tempest, I have left to the Living; for here I am anchord in Peace, waiting the Return of ... Tide of Life.

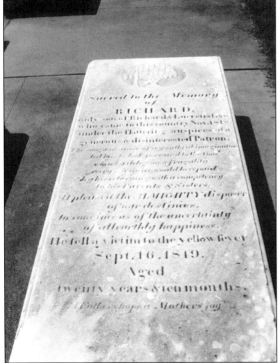

A table tomb's horizontal tablet commemorates one of many early New Orleanians who perished from yellow fever in the epidemics that terrorized the city during many a summer. This one commemorates Richard Law (1799–1819), who had come to New Orleans from England only ten months before his early death.

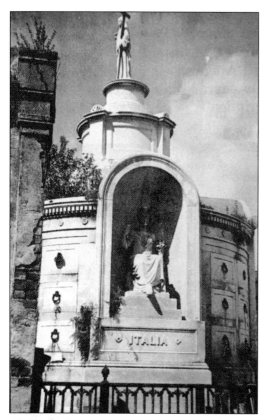

The Italian Society tomb is one of the most prominent in St. Louis I. Society tombs were a common feature of 19th-century New Orleans cemeteries. They were generally built by mutual aid societies for the use of their members. This one, designed by architect Pietro Gualdi, was built in 1848 at a cost of $40,000. Below is another type of multiple tomb—wall vaults, or "ovens" (so called because of the shape of the crypts), which could be purchased or even rented temporarily. Such vaults line the outer walls of many older cemeteries, the oldest being St. Louis I.

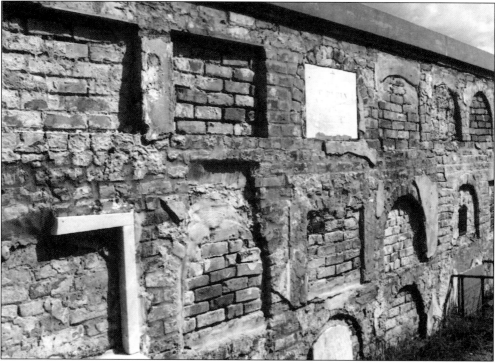

As with the buildings of old New Orleans, the cemeteries feature an abundance of decorative ironwork, both wrought and cast. Unfortunately, many gates, such as this one from the 1850s in St. Louis I, have vanished in recent years. Nevertheless, numerous examples of the art of ironworking continue to grace the city's old burial grounds.

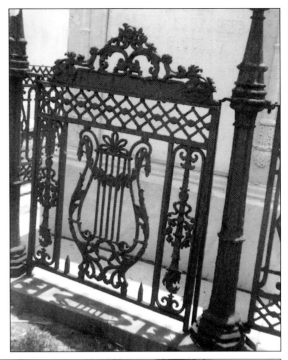

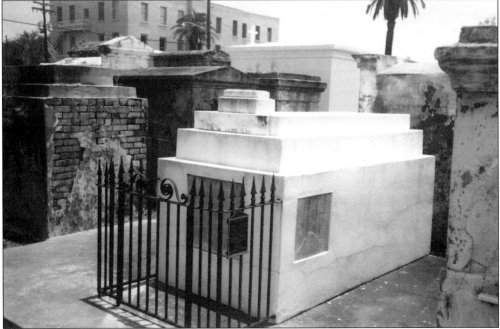

This is the tomb of Etienne de Bore (1741–1820), the first mayor of New Orleans (appointed in 1801) and the first person to granulate sugar on a commercial scale, thereby creating an important industry for Louisiana. Bore's plantation was situated where Audubon Park is located today. On his vault slab is inscribed the Masonic square and compass symbol for Bore, a Catholic, was also a Mason, as were many Catholics in 19th-century New Orleans, a little-known fact today.

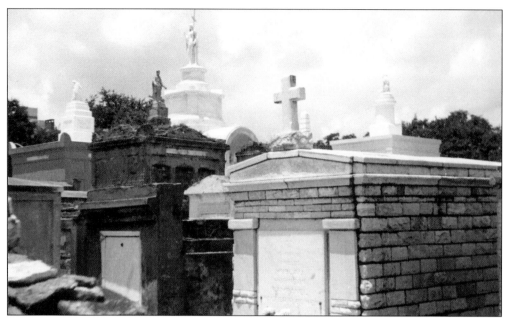

These two photographs show the labyrinthine interior of St. Louis I. There is no order to the cemetery's layout, as can clearly be seen here. The image below offers another view of the Italian Society tomb.

Two more general views show the cemetery's layout. The top view is looking in the direction of the French Quarter and the Mississippi (eight blocks away) from close to the Conti Street side. The mortuary chapel's steeple is visible in the background. In the bottom image the Italian Society tomb rises at center.

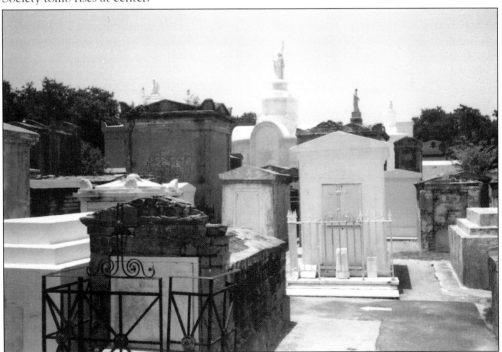

The Conti Street gate of St. Louis Cemetery I is in the foreground; in the background is the Iberville Housing Project, built in 1949 on the site of the infamous red light district called Storyville, which operated legally from 1898 to 1917. Both St. Louis I and St. Louis II were situated within the boundaries of Storyville, and now the Iberville Projects, an exceedingly rough neighborhood, separates the two cemeteries. This same gate, viewed from the outside, may be seen in the 19th-century photograph on p. 9 (it has since lost its arching overthrow). St. Louis Cemetery I was listed in the National Register of Historic Places in 1975, together with St. Louis II.

Two

St. Louis Cemetery Number II

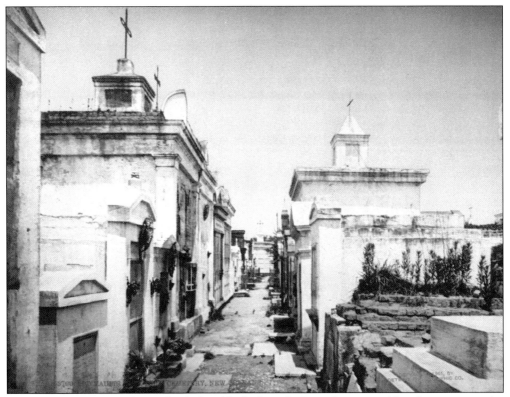

St. Louis Cemetery II is located only four blocks from St. Louis I, separated by what was once the location of Storyville. Unlike St. Louis I, which occupies a single square, St. Louis II comprises three (originally four) squares and is bounded by Robertson, St. Louis, and Iberville Streets and by Claiborne Avenue and the I-10 Expressway. Its squares are separated from one another by Bienville and Conti Streets. St. Louis II was consecrated in August 1823. This view was made by noted photographer William Henry Jackson in 1901, though the cemetery's appearance has changed little since the picture was taken.

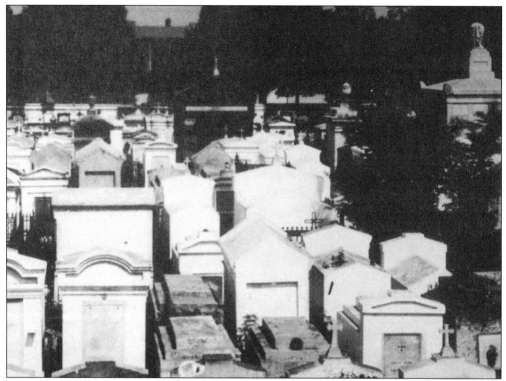

A view of St. Louis II made about 1885 (top) and a modern view from a different angle (bottom) both show the crowded yet regular layout of the cemetery's myriad tombs. In the top photo the large tomb of the Sociedad Ibera de Beneficence Muerta (1843) dominates at far right.

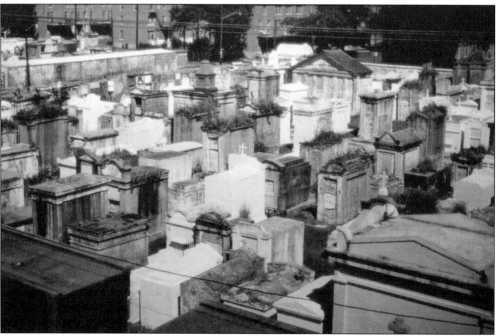

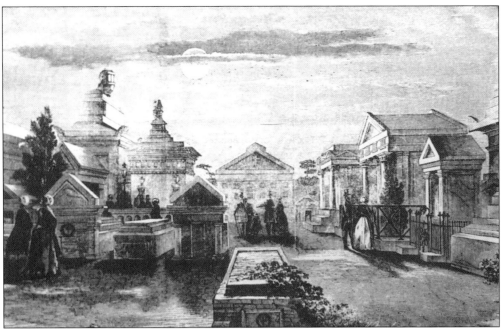

Two 19th-century engravings show visitors to St. Louis II. At top is a view from 1855 that may depict All Saints Day, when New Orleans families traditionally visit the tombs of their ancestors, decorating and cleaning the tombs and their premises. The bottom image, from 1885, is definitely a view of this occasion, which is still widely observed in New Orleans, and throughout Louisiana, today.

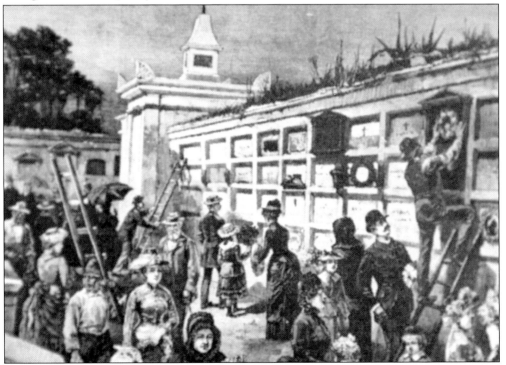

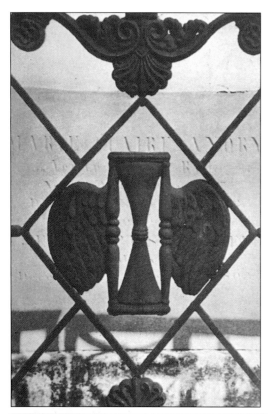

St. Louis II is noted for its abundance of fine ironwork. Examples shown on these two pages include the gate of the Lange tomb (c. 1850), the detail of which depicts the symbolic winged hourglass. Below is a view of the entire gate.

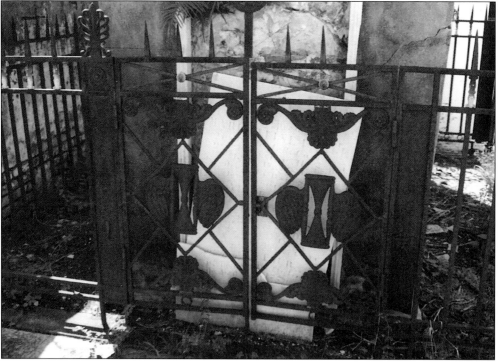

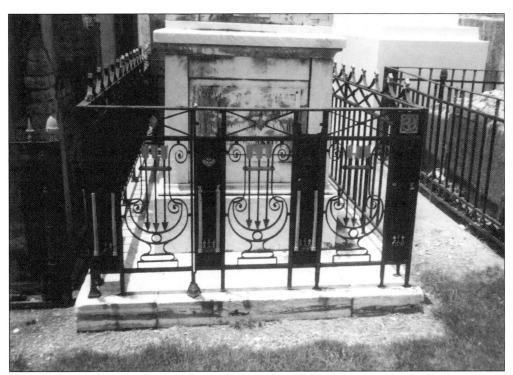

Above is the graceful fence surrounding the Avart tomb. Each panel depicts a lyre composed of three arrows. An identical example is found on another tomb nearby, both in the middle square of the cemetery. The lyre theme is oft-repeated on cemetery ironwork in St. Louis II. Below is a corner of a fence found on the main aisle of square three (nearest Iberville Street). It depicts a pineapple, a symbol of hospitality but also one of hope.

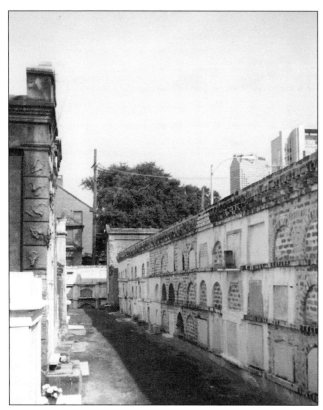

These two general views were taken within St. Louis II. The top photograph shows the wall vaults that surround the cemetery on most of its sides; this particular view is towards the corner nearest Iberville and Robertson Streets. Below is a view past family tombs of the early 19th century toward the wall vaults.

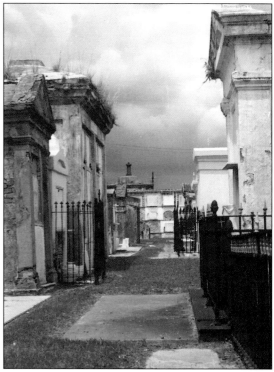

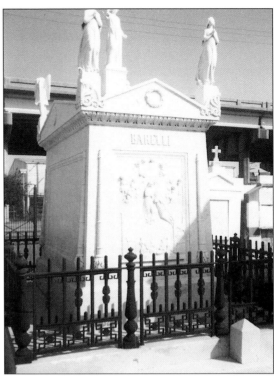

One of the most extraordinary tombs in St. Louis II is that of the Barelli family, located in the middle square of the cemetery. The tomb was designed by Milan native Joseph Barelli (1801–1858) as a memorial to his son, Joseph Barelli Jr., who perished in the explosion of the steamboat *Louisiana* on November 15, 1849, as it was moored at the foot of Gravier Street, about where the Riverwalk stands today. The detail (lower photo) shows the explosion and young Joseph's soul being lifted to Heaven by an angel. The tomb was completed in 1856.

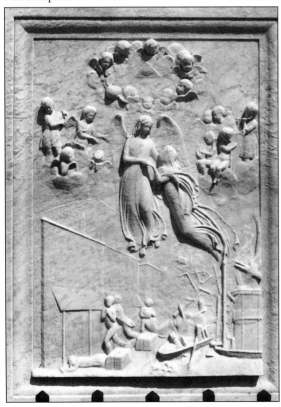

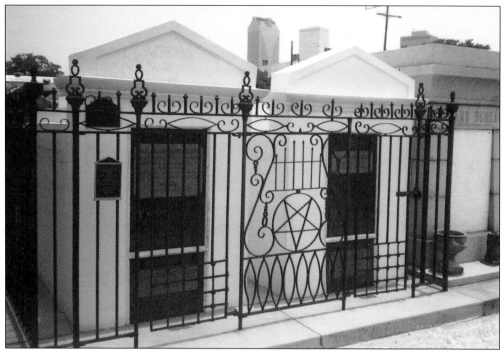

This is the tomb of the second American governor of Louisiana, Jacques Philippe Villere (1760–1830). Villere's father was Royal Naval Secretary of Louisiana under Louis XV, and Villere himself was a royal officer of Louis XVI. After the American takeover of Louisiana in 1803, he served the new government loyally, fighting in the Battle of New Orleans and serving as governor from 1816 to 1820.

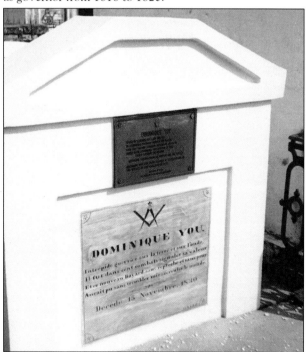

The tomb of the pirate Dominique You, Jean Lafitte's lieutenant at the Battle of New Orleans, is shown here. He later became a city alderman and a well-respected citizen. When he died in 1830 banks were closed and flags flew at half-mast throughout New Orleans. His epitaph reads: "Intrepid warrior on land and sea; In a hundred combats showed his valor; This new Bayard, without reproach or fear; Could have witnessed the ending of the world without trembling."

Undoubtedly the most remarkable epitaph to be found in St. Louis II, or anywhere in New Orleans, is that on the monument that marks the grave of philanthropist Alexander Milne (1744–1838). Built by stonecarver Newton Richards, the gray granite monument contains Milne's entire last will and testament, which created an orphanage called Milne's Asylum for Destitute Boys. The Act incorporating the orphanage is also carved on the monument.

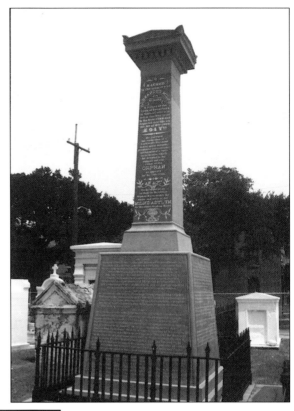

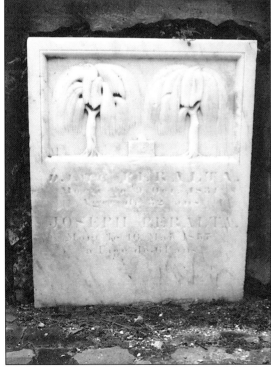

The marble inscription slab on the Peralta family tomb (probably carved 1834) depicts two weeping willows above a tomb. The willow is a frequently occurring symbol in older cemeteries, symbolizing not only death and mourning, but also the proverbial Tree of Life.

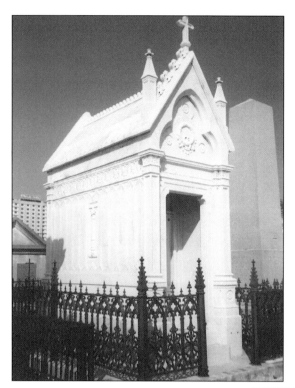

St. Louis II abounds with architecturally important tombs; on this and the next page are shown several examples of these. At top is the Gothic Revival J.M. Caballero family tomb designed by noted architect J.N.B. de Pouilly in 1860. Below is the Graihle family tomb, also by de Pouilly (1850), built in the Egyptian Revival style. De Pouilly himself rests at St. Louis II, in a humbler tomb—an "oven" vault in the wall of square one (the square nearest St. Louis Street).

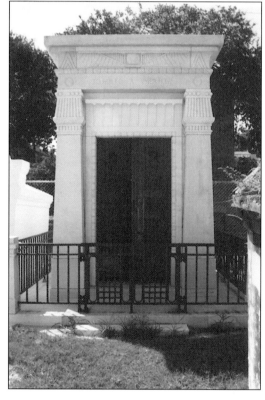

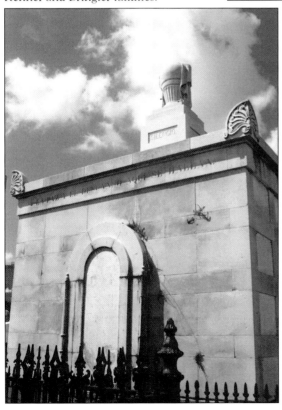

At top is the magnificent Baroque tomb of the Delachaise-Livaudais family, upon whose former plantations now is built much of uptown New Orleans. To its right is the massive Iberia Society tomb, both designed by de Pouilly. Below is a better view of the Iberia Society tomb (see also p. 22). A nearly identical tomb to that of the Iberia Society can be found in the Catholic Cemetery of Donaldsonville, Louisiana, housing the remains of the Kenner and Bringier families.

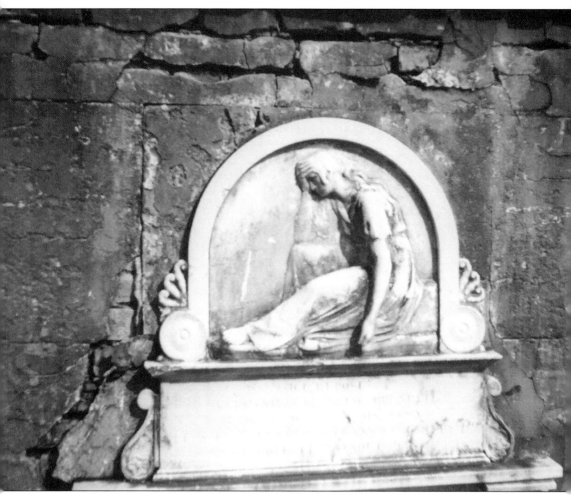

A beautifully executed relief on the tomb of the Brunette family captures the despair, pain, and grief of loss. The scene is made even more poignant by the fact that the marble sculpture has remained fresh while the plaster once covering the brick tomb itself has crumbled away. Among others interred at St. Louis II are General Jean Baptists Plauche (1785–1860), a hero of the Battle of New Orleans; historian and jurist Francois Xavier Martin (1762–1846); Senator Pierre Soule (1801–1870), U.S. ambassador to Spain and Confederate provost marshal; architect James Freret (1838–1897); Claude Treme (1759–1828), whose large landholdings were developed into the Treme neighborhood near the cemetery; Lieutenant Governor Oscar J. Dunn (1821–1871), the first black lieutenant governor in America; Mayor Nicholas Girod (1751–1840), whose house is now the Napoleon House, a French Quarter landmark; and Mayor Charles Genois (1793–1866).

Three

ST. LOUIS CEMETERY
NUMBER III

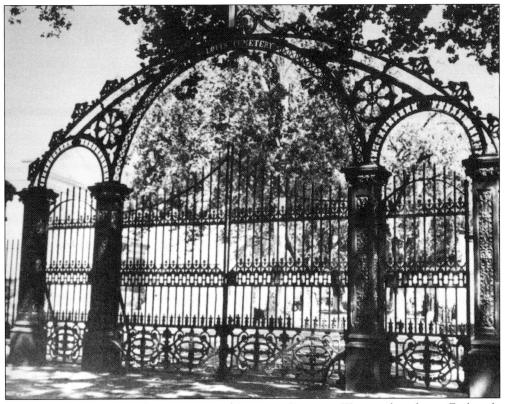

This early photograph of the main gates of St. Louis Cemetery III was taken facing Esplanade Avenue. Made of cast iron by Francis Lurges, who created much of New Orleans' "iron lace" of the mid-19th century, the gates still serve their purpose, though now minus the triple-arch overthrow that once graced them. The cemetery was established in 1854 and is by far the largest of the three St. Louis Cemeteries. Located at the Lakeside end of Esplanade, in Faubourg St. John, it is still very much in use and houses the offices for the St. Louis Cemeteries. Tour busses often make this cemetery a stop because it is easily accessible and much safer than its older and more historic sisters.

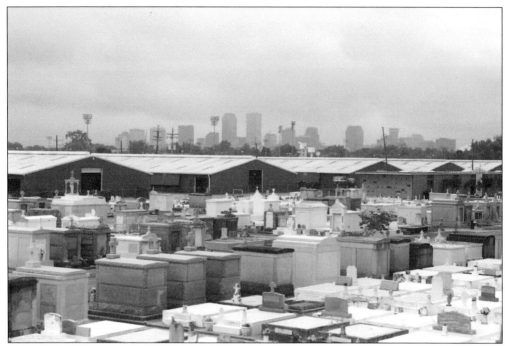

These two bird's-eye views are of St. Louis III. The top photograph shows the New Orleans skyline rising above the cemetery with the sheds of the New Orleans Fairgrounds, where the city's annual Jazzfest is held, in-between. The lower photograph looks from the mausoleum out towards Esplanade. Standing out near the center of the photograph is the tomb of the Hellenic Orthodox Community.

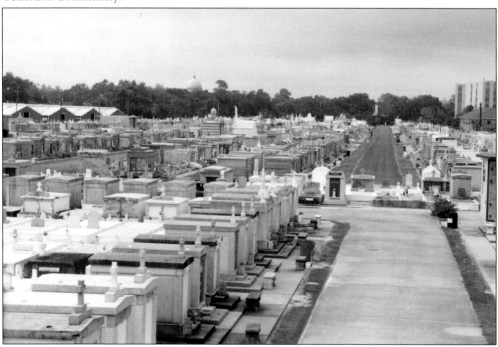

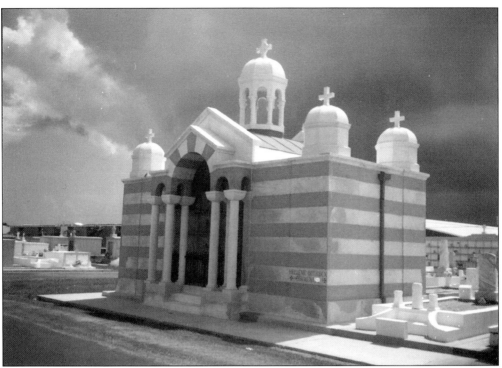

The tomb of the Hellenic Orthodox Community was designed in the Byzantine style in 1928 by Victor Huber and is arguably the most outstanding tomb in St. Louis III. The photograph above was taken in June 1990, as the sun's rays illuminated the tomb just seconds before a torrential downpour.

Another extraordinary structure at St. Louis III is not a tomb at all but a cenotaph—a cemetery monument without a grave beneath. Located near the front of the cemetery, this monument commemorates New Orleans architect James Gallier (1798–1866) and his wife, Catherine Maria Robinson Gallier, who perished when the steamer *Evening Star* sank while en route from New York to New Orleans on October 3, 1866. The Baroque monument was designed by their son, James Gallier Jr.

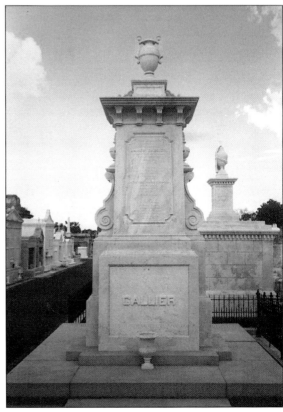

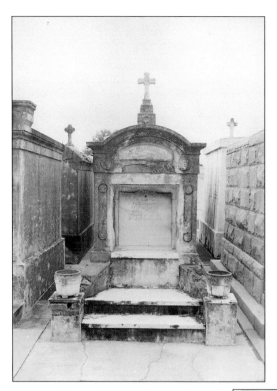

Noted photographer Ernest J. Bellocq (1883–1949) is interred in his family's tomb in the westernmost aisle of St. Louis III. Bellocq is best known for his "Storyville Portraits," images of the old red light district of New Orleans made primarily in 1912 and 1913. His work has been the subject of several books and international exhibitions.

On the main aisle of the cemetery is the LaCroix tomb with its extraordinary cast-iron gate in the form of a willow tree. Similar examples of this gate are found in cemeteries on the East Coast and a few can be found in the South (e.g. in Jackson, Mississippi; Mobile, Alabama; and St. Francisville, Louisiana), but the design is rare in New Orleans. The gate was cast in 1858 and is the only remaining example in a New Orleans cemetery.

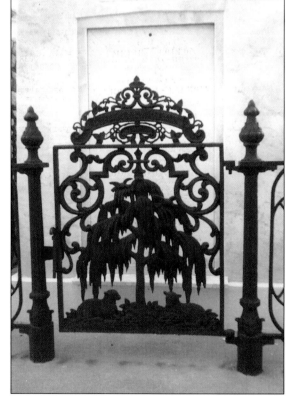

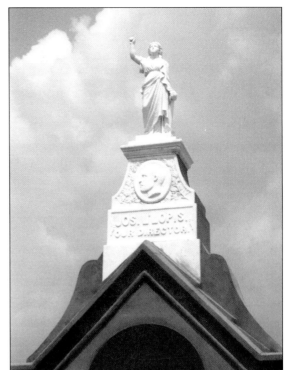

Shown here are two examples of the stonecutter's art in St. Louis III. The many tombs of this cemetery appear at first glance to be very similar to one another, yet upon closer inspection the individuality of each becomes evident. The top image is of the crowning sculpture of a society tomb. The bottom image is a marble figure of a mourning girl nestled in the gable of an otherwise spartan tomb.

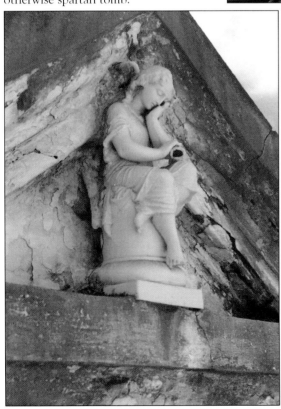

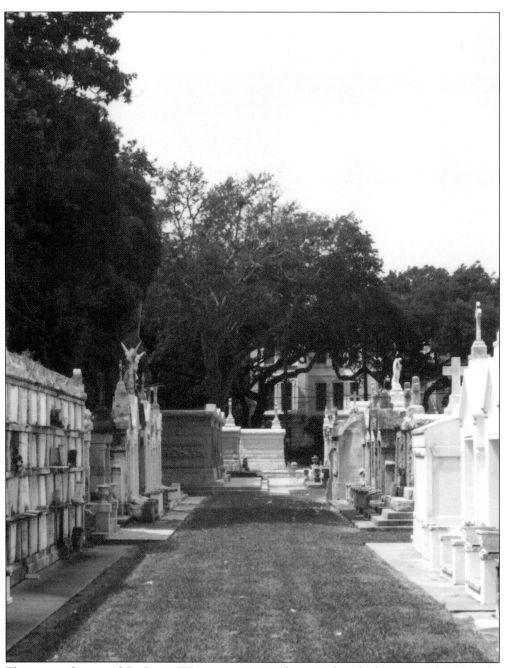

This tranquil view of St. Louis III's easternmost aisle was taken looking toward Esplanade. Among important citizens interred here are Valcour Aime (1798–1867), once one of the nation's largest sugar planters; philanthropist Timothy Lafon (1811–1893); Antoine Michoud (1785–1865), one-time U.S. Consul to Italy; and philanthropist Margaret Haughery (1813–1882), whose statue gracing Margaret Place in a park bounded by Camp, Prytania, and Clio Streets was the first in the United States honoring a woman. Margaret rests in an unmarked vault at St. Louis III, to which her body was moved in 1920 when her first resting place at St. Louis II was demolished.

Four

LAFAYETTE CEMETERIES
I AND II

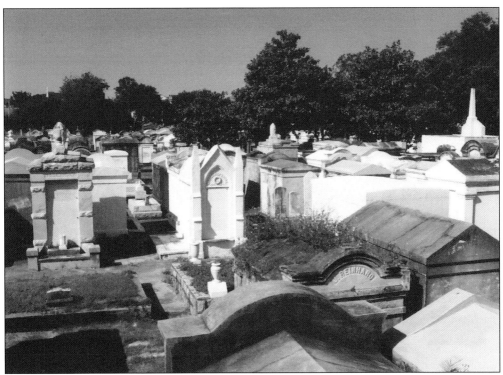

Located in the Garden District opposite the well-known Commander's Palace Restaurant, Lafayette I is bounded by Washington, Prytania, Fifth, and Coliseum Streets. It was established as the municipal cemetery for the then-suburb of Lafayette in 1832, but when the suburb was incorporated into New Orleans in 1852, Lafayette I became a city cemetery. Long neglected in the 20th century, the cemetery was finally cleaned up and restored beginning in 1970. Today it is one of the city's most visited historic cemeteries.

The above view from the center of Lafayette I shows the communal tomb of the Jefferson Fire Company Number 22. Volunteer fire companies were important facets of old New Orleans, providing both a social and fraternal element to their members (who were frequently prominent citizens) and fire protection to the vulnerable city. Below is a detail from the same tomb—a relief carving of a fire pumper from the time the tomb was built, 1852.

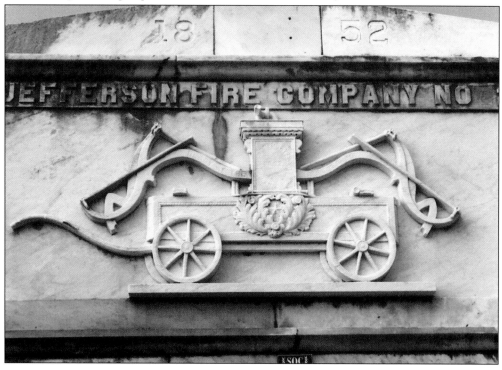

Among prominent families interred in Lafayette I are the Pitkins. J.R.G. Pitkin was ambassador to Argentina under President Benjamin Harrison. His daughter, Helen Pitkin Scherz (1877–1945), was a well-known writer who restored and resided in the old Spanish customhouse on Moss Street, facing Bayou St. John.

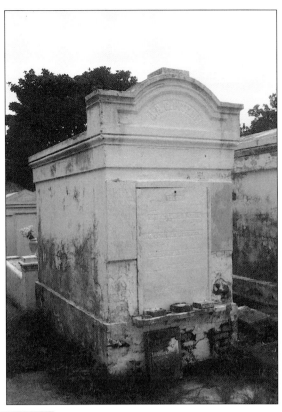

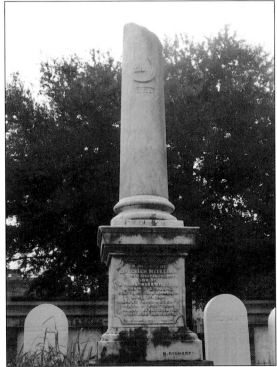

A notable grave site is that of Captain Charles W. McLellan (1842–1864), a Confederate officer and a native of Maine. His family is said to have shipped earth to New Orleans from Maine after the war so he could be buried in Maine soil. The monument is by New Orleans stonecarver Newton Richards.

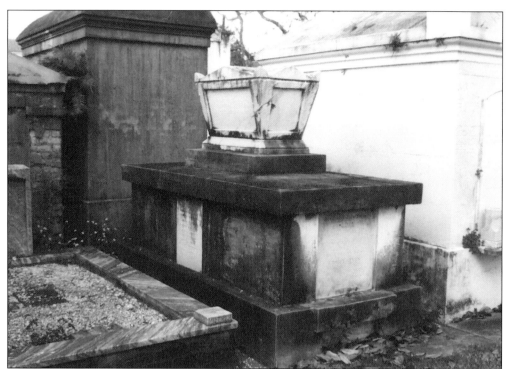

Yellow fever was the scourge of warm weather months in 19th-century New Orleans. Its origins and pathology were unknown before 1900, and thousands died in epidemics that sprang seemingly from nowhere. Numerous monuments attest to this fact, as with this Neo-Classical tomb, in which rest all members of a family who died in the epidemic of 1878. The tomb is by Kursheedt & Bienvenu, stonecarvers, of New Orleans.

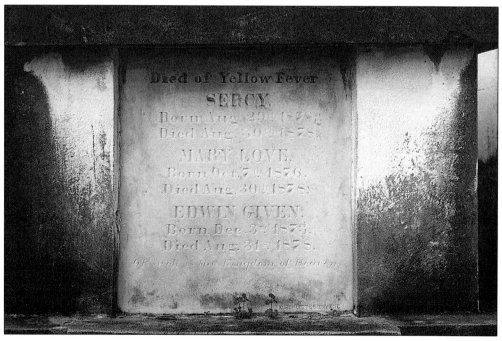

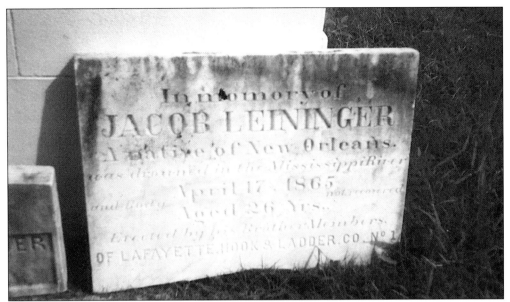

The small marble monument above commemorates Jacob Leininger, a member of Lafayette Hook & Lader Company No. 1, who was 26 when he drowned in the Mississippi River on April 17, 1865. His body was never recovered. The tomb in the photograph below is that of the Hyams family, a prominent Jewish family of Charleston, South Carolina. Henry M. Hyams was lieutenant governor of Louisiana under Governor Thomas Overton Moore, the first Confederate governor of the state. A monument to General Henry Watkins Allen, the second Confederate governor of Louisiana, is located at Lafayette I, but Governor Allen's remains rest in Baton Rouge.

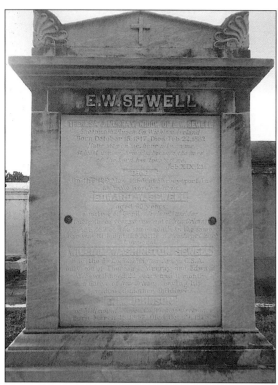

The tomb of the Sewell family bears an inscription that reminds visitors of the hardships of the Civil War: "Died on May 12, 1864 at Shreveport, La, an exile from his home, Edward W. Sewell, aged 60 years." Just below that is the following inscription: "On the 28th of the same month was killed at the Battle of New Hope Church Corp. William Washington Sewell aged 22 years . . . leaving his widowed mother childless."

The Karstendiek tomb is built entirely of cast iron and dates from the 1860s. Cast-iron tombs, while the exception in New Orleans, are not all that rare; yet in Lafayette I this one, designed in the Gothic Revival style, is unique.

Epidemics were the chief reason for the large number of orphans that populated New Orleans during the 19th century. Most orphanages had communal tombs, and several examples of these sad relics of the past are found in Lafayette I. This is a late example, dating from 1894, but it is representative of similar tombs built throughout the century.

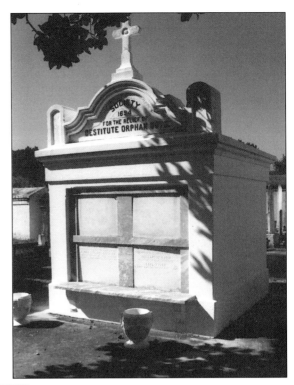

The high brick walls of Lafayette I conceal the ancient tombs of this venerable cemetery from the daily life of the Garden District and of busy St. Charles Avenue, only a block away. Among other prominent citizens entombed here are Confederate General Harry Thompson Hays (1820–1876) and New Orleans real estate developer Samuel Jarvis Peters (1801–1855), for whom North and South Peters Streets are named. Lafayette Cemetery Number I was listed in the National Register of Historic Places in 1972.

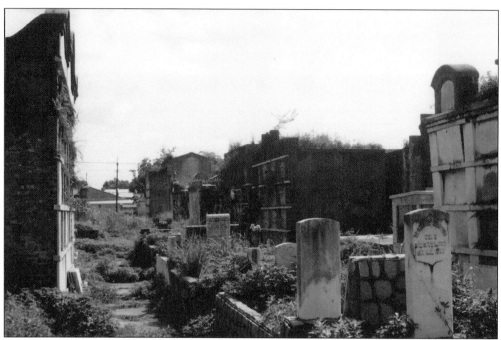

Just seven blocks north of Lafayette Cemetery Number I is the less well-known Lafayette Cemetery Number II, bounded by Washington Avenue and Saratoga, Sixth, and Loyola Streets. Despite being so near, the two cemeteries are in markedly different neighborhoods and markedly different states of repair, as the photographs on this and the following two pages attest. Below is the tomb of Eagle Fire Company Number 7.

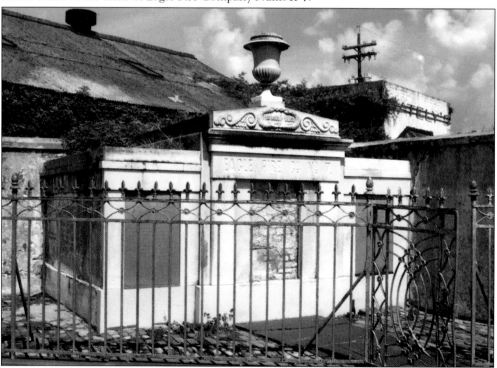

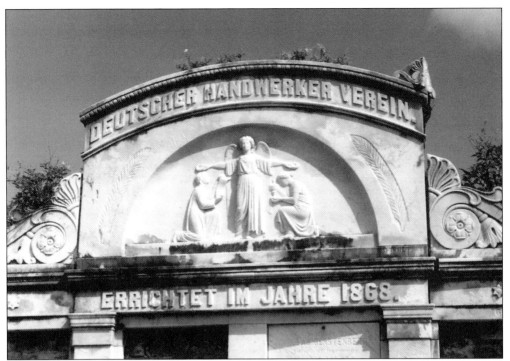

Lafayette II opened about 1850 and contains numerous fine society tombs, though most have been neglected and are deteriorating. In 1973 the wall vaults were demolished and a chain link fence now surrounds the cemetery. Details of two society tombs are shown on this page. Above is the 1868 German Trade Association tomb, designed by Anthony Barrett in 1868. Below is the Cotton Yard Men's Benevolent Association Number 2, erected in 1886.

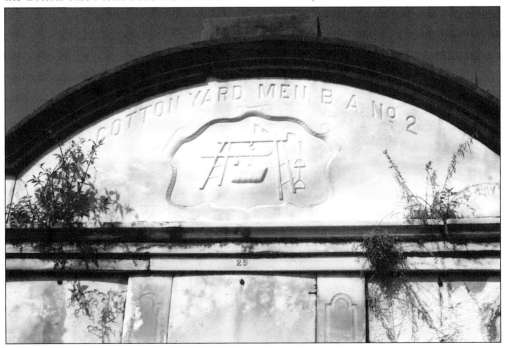

The French Mutual Assistance Society tomb, photographed in 1994, was built in 1872. The numerous society tombs are the sole elements that make Lafayette II noteworthy, for there are few notable people interred here and few notable private tombs. Across Loyola Street are St. Joseph Cemeteries Number I and II, founded in 1854 and 1873, respectively, by the German Catholic community. The St. Joseph Cemeteries contain a few noteworthy family tombs as well as a chapel built in 1844 by St. Mary's Assumption Church and moved to the cemetery in 1862.

Five

THE JEWISH CEMETERIES

Though the Inquisition forbade Jews and Protestants to settle in Catholic Louisiana during the Spanish period, many did so nevertheless, and in 1803, when the United States acquired the territory, a small Jewish population already dwelt in New Orleans. In 1827 the first synagogue outside the original 13 colonies was formed at New Orleans (today's Touro Synagogue) and a year later the first exclusively Jewish cemetery was consecrated on Jackson Avenue (its graves were moved in 1957). A dozen more Jewish cemeteries, counting the two Jewish sections of Metairie Cemetery, have come into existence since then, though several have been merged. Shown here are the Elysian Fields Boulevard gates of Hebrew Rest Cemetery, founded in 1872. The cast-iron gates were made for the Centennial Cotton Exposition of 1884 and later acquired for the cemetery.

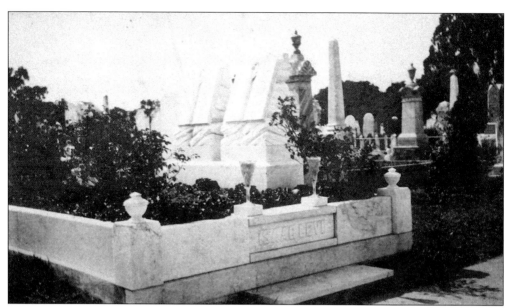

Hebrew Rest Cemetery covers three square blocks, the most important of which, historically, is that bounded by Elysian Fields, Pelopidas, Frenchmen, and Senate Streets. Above is a view from 1897 of the Isaac Levi (1830–1896) lot, located near Pelopidas and Elysian Fields. Below is the same lot in 1998. Its large monument, having been moved, now faces north instead of east, as do the graves.

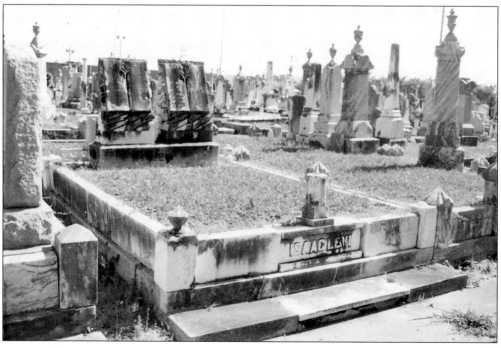

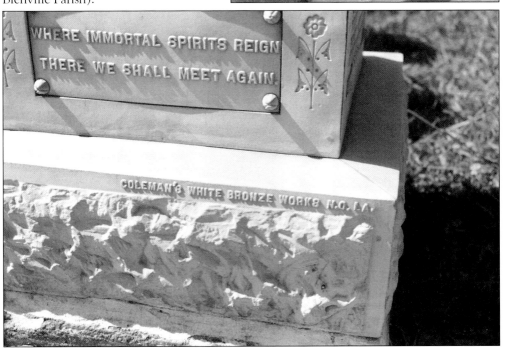

The Stern monument (1885) at Hebrew Rest is a diminutive but important grave marker. It is made of cast zinc (commercially known as "white bronze"), a common Victorian grave marker material nationally but scarcely found in New Orleans. Its importance, however, lies in the fact that it was made in New Orleans by a foundry called Coleman's White Bronze Works. The marker is signed (below) and is one of only two signed Coleman's examples known in Louisiana (the other is in the city cemetery of Arcadia, in Bienville Parish).

WHERE IMMORTAL SPIRITS REIGN
THERE WE SHALL MEET AGAIN.

COLEMAN'S WHITE BRONZE WORKS N.O. LA.

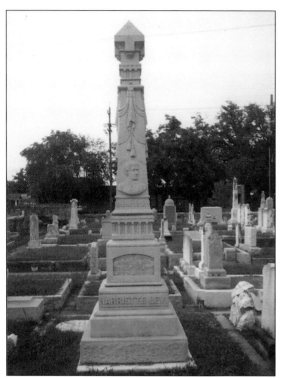

The large white bronze monument to Harriette Dreyfuss Levi (1844–1883) is an outstanding example of portraiture. Located near the Frenchmen Street gate of Hebrew Rest, it bears a relief likeness of Mrs. Levi (detail below), a native of New Orleans and wife of Shreveport jeweller I.C. Levi.

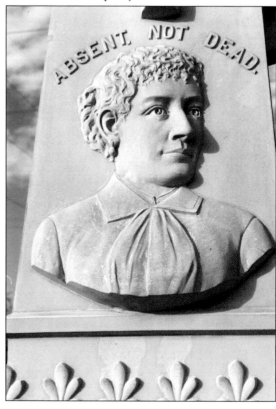

The Levy family lot at Hebrew Rest bears two large Victorian memorials erected in 1898. The sculpture of the angel strewing flowers, a rare motif in a Jewish cemetery, is a monument to Sam Levy, who died at the age of 21, and Irma Levy, who died at the age of 18. Next to it is a broken column, symbolic of life cut short, a monument to Henry Levy, who was 33 when he died.

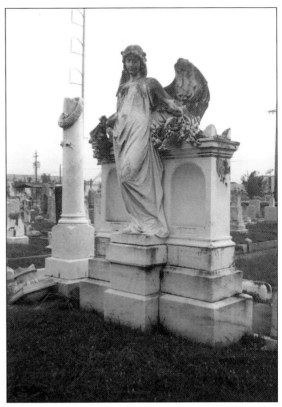

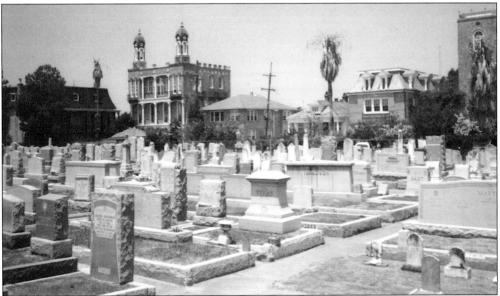

The oldest extant Jewish cemetery in New Orleans is Gates of Prayer on Canal Street at Bernadotte. Founded in 1846 as Dispersed of Judah Cemetery, it absorbed the adjacent Tememe Derech Cemetery (1850) in 1939 and was re-named Gates of Prayer. In 1950 the adjacent Beth Israel and Chevra Thillim Cemeteries were also absorbed, and in 1957 the graves from the Jackson Avenue Jewish Cemetery (1828) were relocated here.

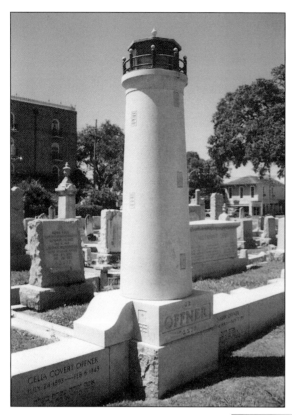

Among the many prominent New Orleanians buried at Gates of Prayer on Canal Street are Harry Offner (1880–1951), a hardware merchant who dedicated his life and resources to the Lighthouse for the Blind. His monument is a replica of the Lighthouse building on Camp Street. Also buried here is clothing merchant Simon Haspel (1842–1916), whose ready-to-wear Haspel suits were famous.

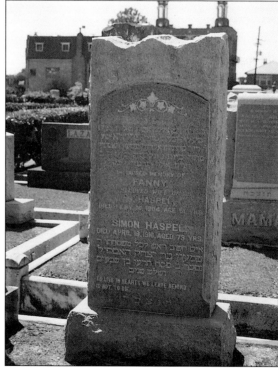

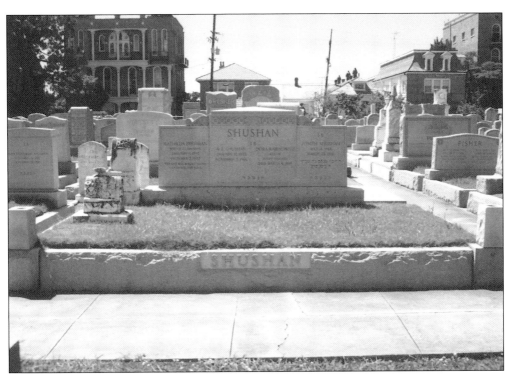

Abe Shushan (1894–1966) rests at Gates of Prayer, Canal Street. Shushan was a prominent dry goods merchant and an important figure in the inner circle of Governor Huey P. Long. He promoted the need for a municipal airport for New Orleans and lobbied hard for state money to build one. Thus Lakefront Airport, originally called Shushan Airport, was constructed.

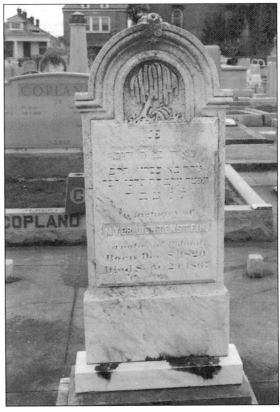

An early monument depicts the weeping willow motif. The older stones are replete with Hebrew inscriptions, many of them far more poetic and informative than the English. On some older stones there is no English at all. This one marks the grave of Myer Lichtenstein (1820–1867), a native of Poland. Most early New Orleans Jews were German or Alsatian French but many were from Poland and Russia. The Offner monument is visible in the background.

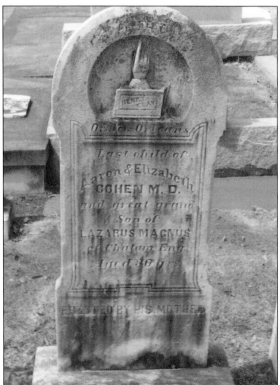

Like their non-Jewish neighbors, New Orleans Jews were loyal to the South and, when war came, to the Confederacy. Examples of Southern patriotism can be found in the names given to children just before and during the Civil War, such as seen here on the marker of Henry Clay Cohen (not dated but *c.* 1880), who died at the age of 30. The epitaph also notes that he was a descendant of the notable Magnus family of Great Britain.

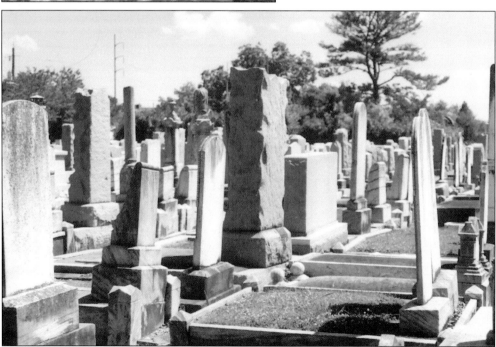

This general view of a corner of Gates of Prayer, Canal Street, shows the densely packed lots reminiscent of Eastern European Jewish cemeteries. Nearly every inch of available ground has been used for burials.

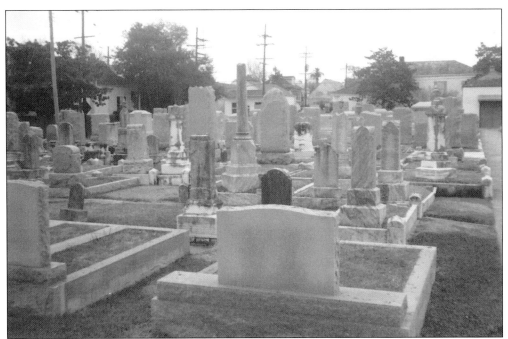

The Uptown part of New Orleans also has an early Jewish Cemetery called Gates of Prayer (above), fronting on Joseph and Arabella Streets, just three blocks south of St. Charles Avenue. Founded in 1850, it was first surrounded by a brick wall, which was replaced in 1897 by an iron fence. The cemetery also boasts the only remaining Metaher (ceremonial chapel) remaining in New Orleans (below). Dating from the 19th century, it was restored in the 1990s.

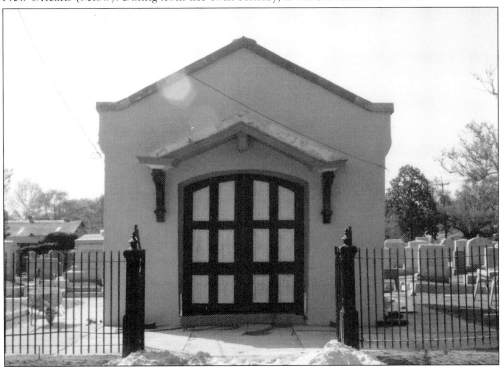

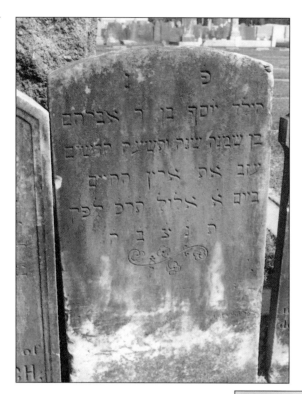

As with many of the stones in early Jewish cemeteries, numerous markers at Gates of Prayer, Joseph Street, contain no English. The top image is an example of a stone (c. 1850s) carved only in Hebrew, commemorating one Isaac ben Reb Avraham. Below, in Hebrew and German, is the marker of Jacob Moise, born in Alsace, who died in Magnolia, Mississippi (c. 1860s).

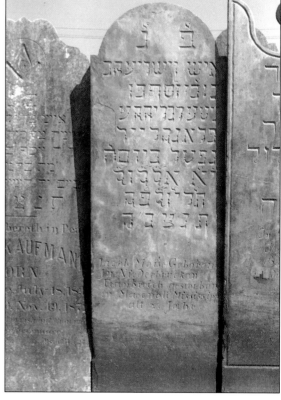

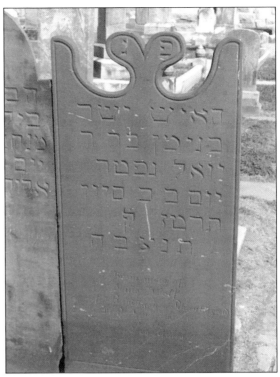

The early slate marker to the left commemorates Louis Wolf, a native of Germany who died in 1856. There are numerous similar markers from the same era, many with the distinctive jigsaw-like crowns seen here. In the late 1970s these stones were unfortunately removed from their original grave sites and packed together in rows, as seen below. Some were placed along the Arabella Street fence. The original grave spaces were then re-sold and re-used.

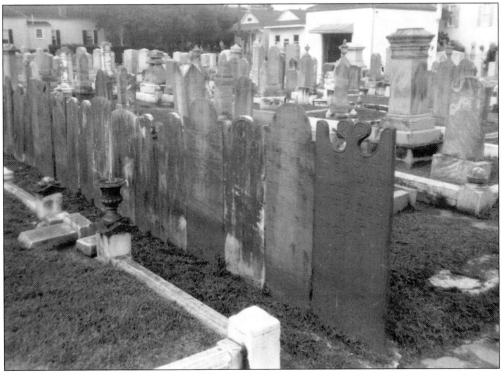

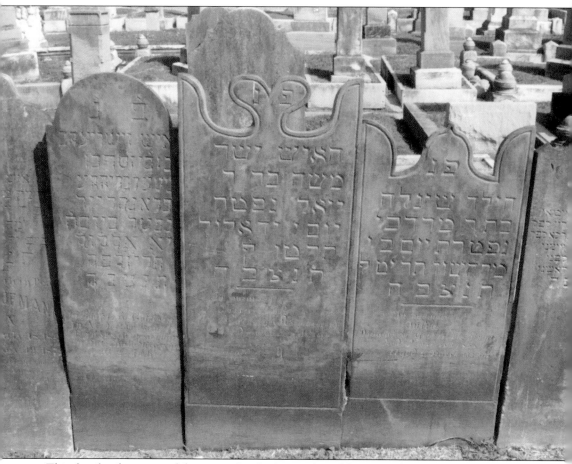

This detail is from one of the rows of early slate and marble stones that were moved from their original sites in the 1970s. The stones date primarily from 1850 to 1875 and contain numerous symbols, including the Hebrew letters "pei nun" (for "poh nikbar," meaning "here lies buried"), willow trees, and Masonic symbols. The Star of David did not come into common usage on grave markers until early in the 20th century. These stones are usually very thin, often no thicker than an inch, yet have withstood a century and a half of existence.

Six

CYPRESS GROVE
CEMETERY

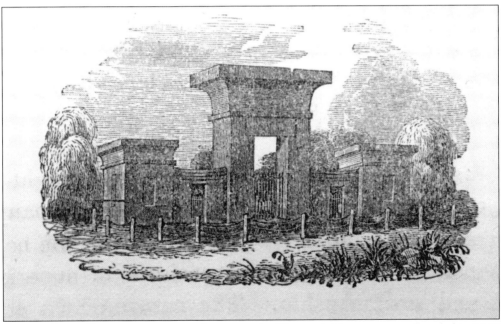

Cypress Grove Cemetery, sometimes known as the Firemen's Cemetery, was founded in 1840 by the Firemen's Charitable and Benevolent Association using funds left to the organization by a wealthy businessman and volunteer fireman, Stephen Henderson. The massive Egyptian Revival-style gates were built shortly afterward and were designed by engineer Stephen Wilkinson. The engraving shown here portrays the gates as they appeared in 1845. Today they are much the same, though now missing the massive lintel above the central portion. These main gates face Metairie Road at its convergence with Canal Street and City Park Boulevard. At this intersection a cemetery is located on every corner. Cypress Grove's layout is narrow but deep, extending back to Banks Street, on which there is a rear entrance.

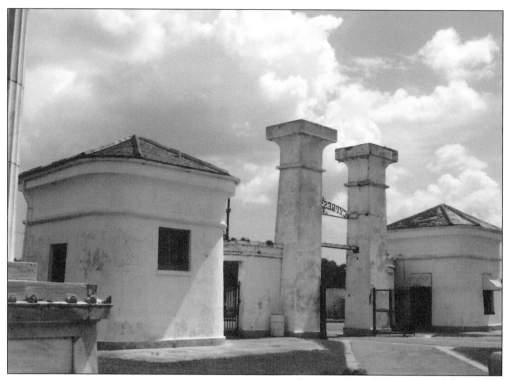

Cypress Grove's main gates (above) are shown from inside the cemetery, 1998. The gates were erected at a cost of $8,000 and now house the office of the cemetery caretaker. Below is a cast-iron wheel guard, one of many relics of the age of carriages still found in Cypress Grove and the nearby Greenwood Cemetery.

Near the main entrance to the cemetery is the impressive tomb of Irad Ferry (1801–1837), the first person to be buried at Cypress Grove. The tomb was designed by J.N.B. de Pouilly and features a broken pillar, symbolizing life cut short, as well as a detailed bas relief of an early fire pumper (below). Ferry was mortally injured fighting a New Year's day fire in 1837 on Camp Street. He died on January 4 and was originally buried at Girod Street Cemetery. When Cypress Grove was dedicated his remains were moved here with great pomp, and in 1841 this grand memorial was built.

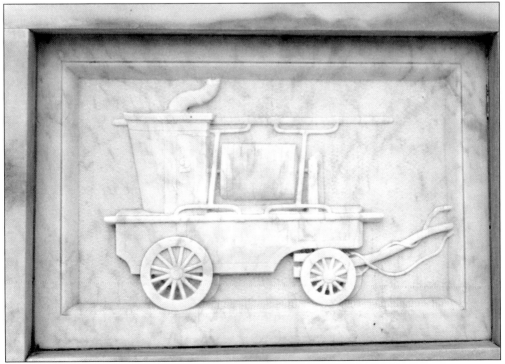

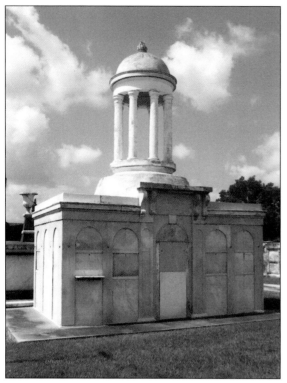

Close by the Irad Ferry monument is the communal tomb of the Perseverance Fire Company Number 13 (left), designed by architect John Bennett and built in 1840. Also nearby are the tombs of Philadelphia Fire Engine Company No. 14 and Eagle Fire Co. No. 7, both from the same era. Many of Cypress Grove's individual gravestones also commemorate firemen, such as the monument to W.H. Webb (1841–1884), below.

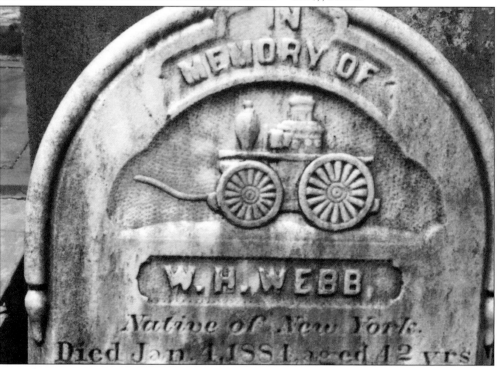

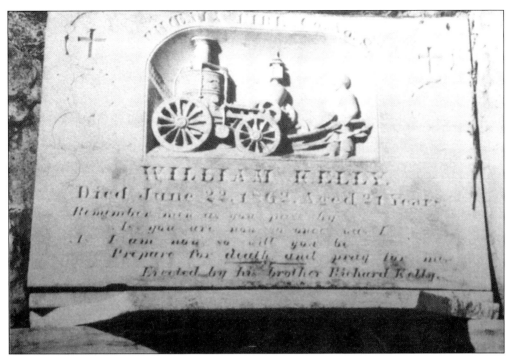

Numerous wall vaults, which line either side of the cemetery, bear plaques honoring deceased firemen, though many of these plaques have vanished through the years. Among extant examples are the tombstones of William Kelly (1840–1862), above, and J.F. Krieg (1811–1844).

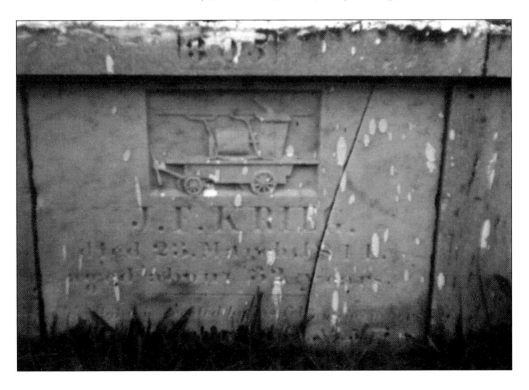

The wall vaults to the left line the eastern side of Cypress Grove Cemetery. This particular group of vaults separates Cypress Grove from Charity Hospital Cemetery next door. The strikingly beautiful white marble bas relief of a grieving young mother comforting her child at a graveside (below) adorns the tomb of the May family (1850).

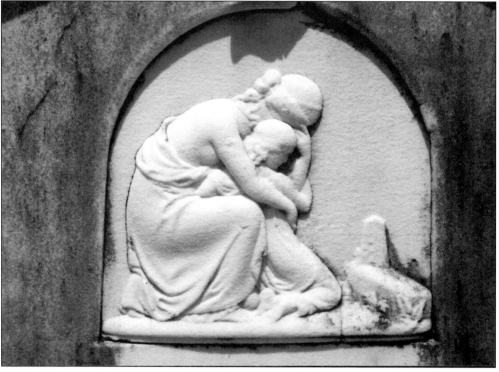

Above is the tomb of Maunsel White (1783–1863), planter and statesman, who is best remembered for inventing pepper sauce, now a staple of Louisiana cuisine. He reposes in a Greek Revival-style tomb designed by J.N.B. de Pouilly. In the photograph below, faces stare out from the corners of a sarcophagus-style tomb on Cypress Grove's central aisle (c. 1845). The form is found on many New Orleans tombs designed by de Pouilly.

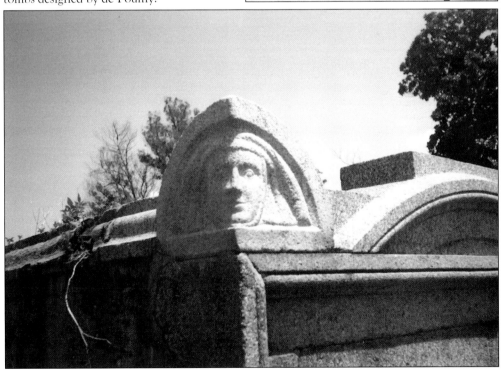

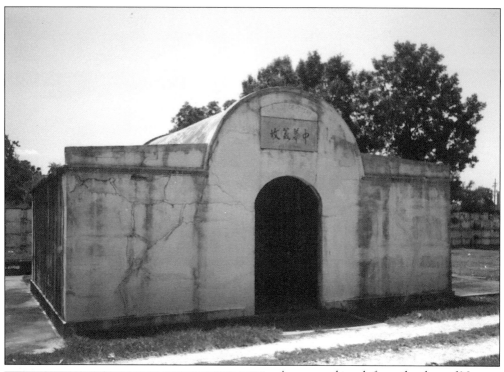

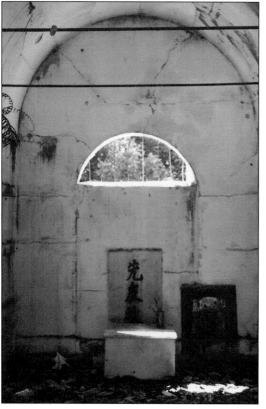

An unusual tomb from the days of New Orleans' once-famous Chinatown is the Soon On Tong Association's communal tomb (above), with its altar (below), which is occasionally still used. Built in 1904, the tomb was originally a temporary holding facility for the remains of Chinese New Orleanians, who were eventually shipped to China for interment or cremation.

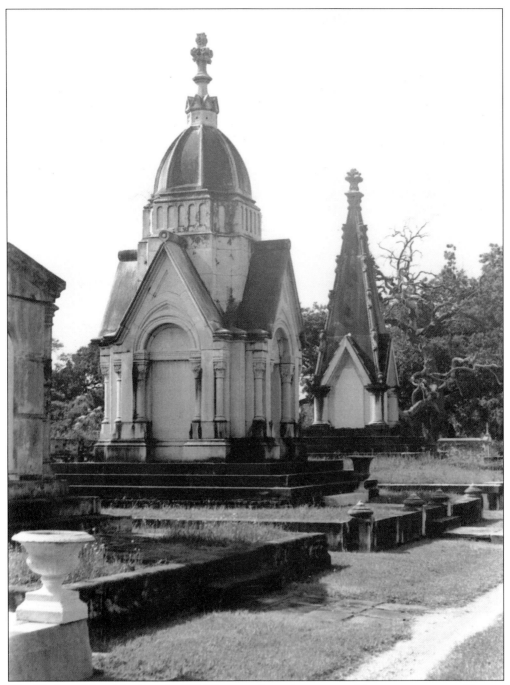

The Slark and Letchford tombs (1868) are perhaps the most striking monuments at Cypress Grove. Designed in an eclectic style that blends Gothic and Romanesque elements, the tombs are each perfectly symmetrical on all four sides. The gnarled yet majestic oak in the background is probably nearly as old as the tombs, which house members of two related families.

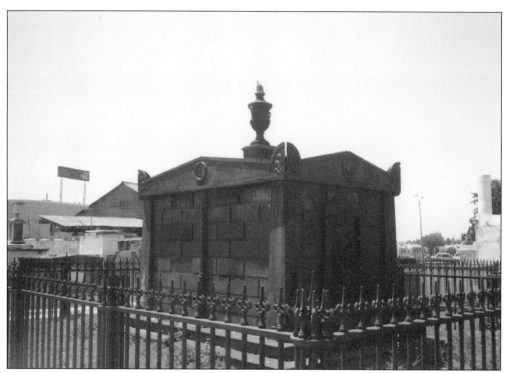

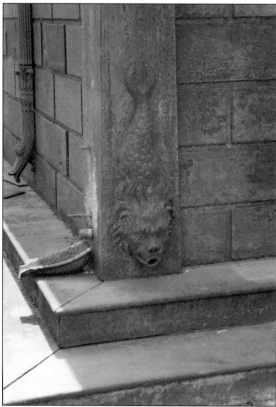

The cast-iron Leeds tomb is located not far from Cypress Grove's main entrance. The Leeds family owned the Leeds Foundry, which produced this tomb and surrounding fence in 1844. It is one of the oldest examples (possibly *the* oldest) of cast-iron tomb architecture in New Orleans. The downspouts (below) are in the shape of sea monsters, their mouths emitting runoff into iron seashells. Several of these elements have vanished from the tomb over the years. Charles Leeds was mayor of New Orleans in the 1870s.

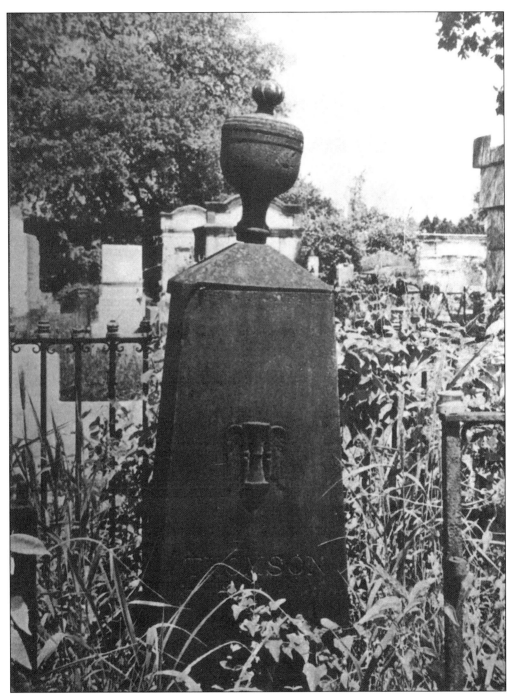

Another early example of cast-iron funerary architecture was the Thomson monument, once located in a lot on the main aisle of Cypress Grove. Dating from the 1840s, the Thomson obelisk bore a large top-shaped finial that disappeared by the 1950s. During the 1960s the entire monument vanished. It is seen here in a 1940s photograph. While all New Orleans cemeteries have suffered losses of artistic elements through the years (especially in the 1980s and 1990s), it seems that Cypress Grove has suffered inordinately.

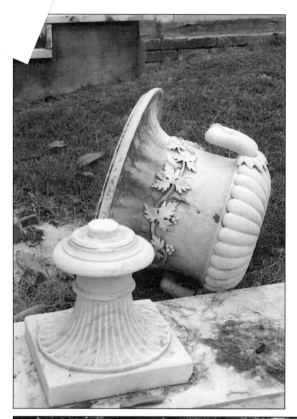

Marble is a soft stone and easily broken, both by the ravages of time and by vandals. The above piece is from the second half of the 19th century. A weeping willow below adorns the tomb of Katie McIlhenny Smith (1850–1869), who died in childbirth a month after her 19th birthday. Her despondent husband, J. Pinkney Smith, wrote her epitaph: "Soon as she found the key of life, it opened the gates of death." Beneath the willow are two hearts, one with Katie's name, the other blank for their unnamed baby.

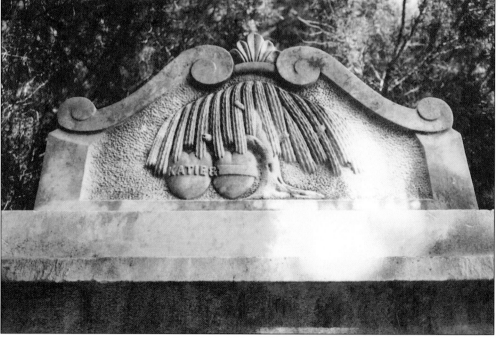

Seven

GREENWOOD CEMETERY

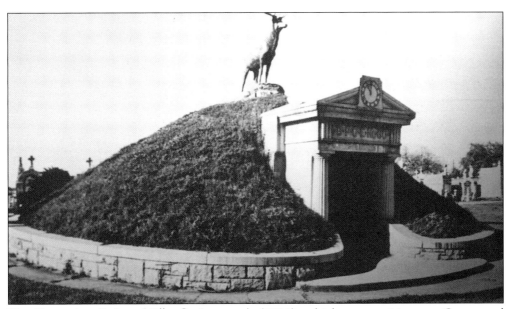

The Protective Order of Elks Society tomb (1912), which greets visitors to Greenwood Cemetery, looks out toward the intersection of Canal Street, Metairie Road, and City Park Boulevard. Greenwood's main entrance is at the foot of Canal Street but the cemetery also has entrances along Canal Boulevard. Like Cypress Grove across the street, it was established by the Firemen's Charitable Benevolent Association. Founded in 1852, Greenwood is one of New Orleans' largest cemeteries and is still very much in use.

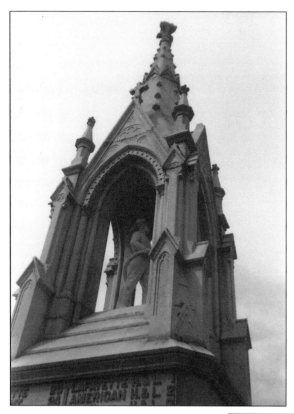

The Firemen's Monument (1887) stands near the Elks tomb at Greenwood's entrance. The monument was designed by stonemason Charles A. Orleans, and its central statue was carved by sculptor Alexander Doyle of New York. It stands 6 feet high and honors the city's volunteer firemen, who were the only firefighters in New Orleans prior to the creation of a paid fire department in 1891.

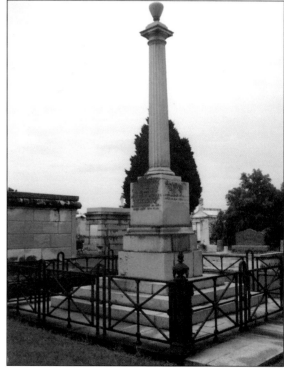

Not far from Greenwood's Metairie Road gate is the grave of Mayor Abial Daily Crossman (1803–1859), who led the city from 1846 to 1854, during which the disastrous yellow fever epidemic of 1853 struck.

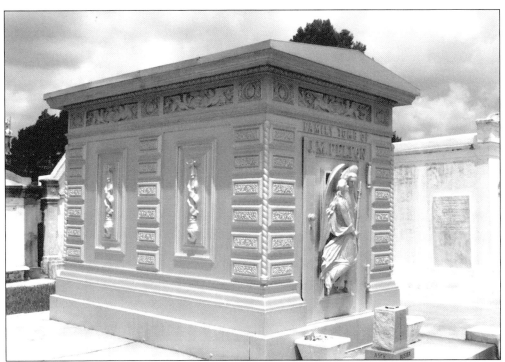

The Pelton tomb is one of two identical cast-iron tombs at Greenwood, the other being the Miltenberger tomb. Both were made by the firm of Wood & Miltenberger and date from the mid-19th century. The Wood and Miltenberger firm was a partnership between Robert Wood of Philadelphia and the Miltenberger foundry of New Orleans. Additionally, Greenwood boasts a number of other cast-iron tombs of varying designs.

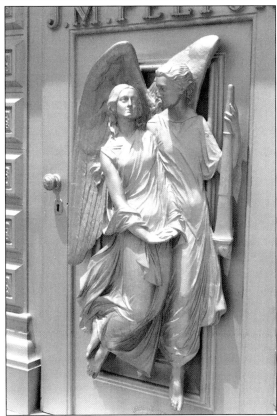

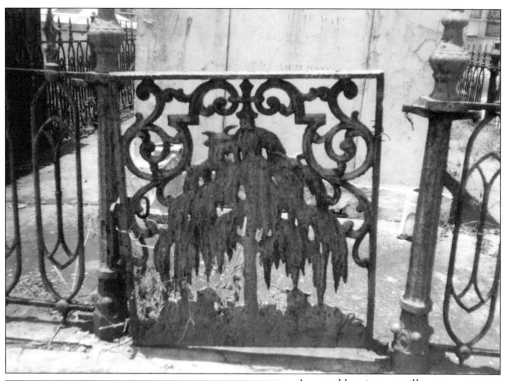

A rusted but intact willow tree gate made by Robert Wood of Philadelphia (1850s) once graced the enclosure of the Waters tomb. Similar to one that remains intact at St. Louis III (see p. 26), it has disappeared since this photograph was taken in 1989.

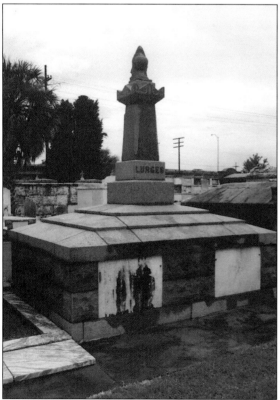

The massive but squat granite tomb of the Lurges family (c. 1880s) stands not far from the Crossman and Waters tombs in the southwest portion of Greenwood Cemetery. The Lurges foundry was, together with Leeds, Shakespeare, Miltenberger, and Reynolds, one of the principal ironworks of mid-19th-century New Orleans.

This bizarre and much-photographed enclosure consists of a cast-iron fence surmounted by three arched iron bands, the middle of which supports a lantern-like double shrine, long since missing its icons. At each corner is a large iron cross set in an iron ring and surmounted by a small cross. The enclosure surrounds the in-ground burials of the Mahon family.

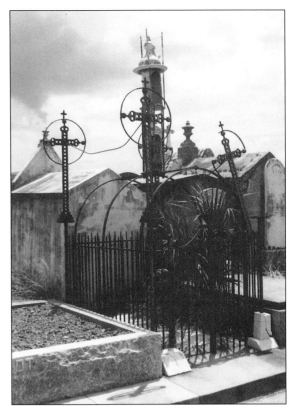

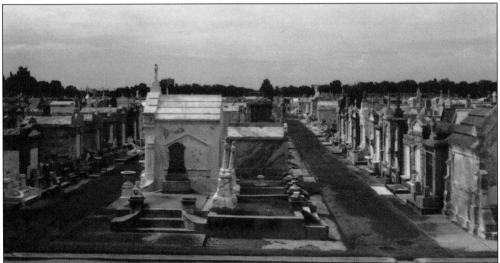

This general view shows Greenwood Cemetery looking north. The cemetery's more than 150 acres contain tens of thousands of tombs, including those of several mayors, two Confederate generals, Young Marshall Moody (1822–1866) and Thomas Moore Scott (1829–1876), and one Union general, William Plummer Benton (d. 1867). This cemetery is the first one many visitors to New Orleans see as they enter the city by car from I-10 (the Pontchartrain Expressway) or by rail on AmTrack. Writer John Kennedy Toole (1937–1969) is also buried here.

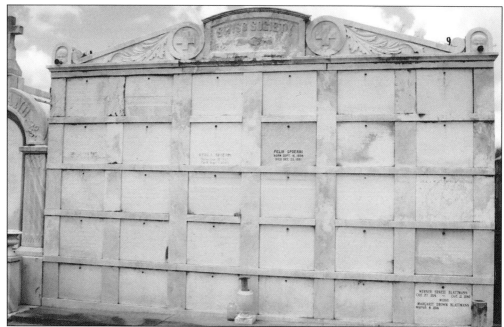

The otherwise common style of the Swiss Society tomb (above), built in the 1870s, is rendered unique by the corner caps (below), which depict the face of a child or cherub blowing a horn. Greenwood has many society tombs of all sorts, including those of fraternal, religious, ethnic, military, and trade groups. There are also wall vaults along its western edge and a massive modern mausoleum at the northernmost end. Cypress Grove II, once separated from Greenwood's eastern edge by wall vaults, was destroyed, along with the wall vaults, in 1911.

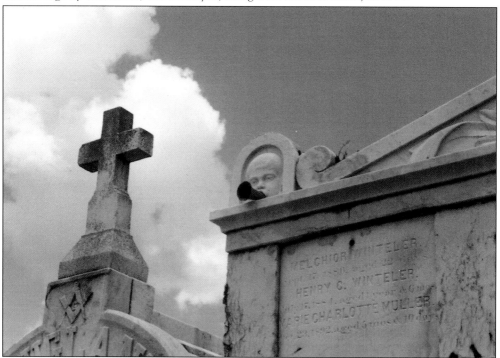

Eight

METAIRIE CEMETERY

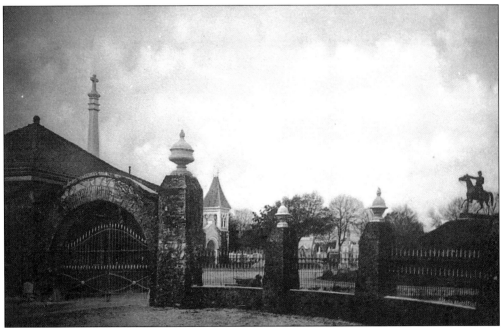

Metairie Cemetery is located within the city limits of New Orleans on the border with the suburb of Metairie. Metairie Cemetery was established in 1872 on land that had formerly been the Metairie Racecourse (interestingly, part of this property had been used for impromptu burials during the great yellow fever epidemic of 1853). Consequently, the cemetery is shaped like a racetrack, its roads running in huge concentric ovals. Several additions have been made to the original cemetery grounds over the decades; the largest of these was the merger of adjacent Lake Lawn Park to Metairie Cemetery in 1969. The photo above shows the original entrance on Metairie Road about 1900.

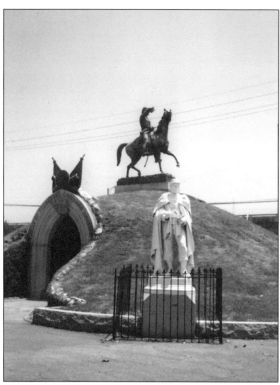

Near the corner of Metairie Road and Pontachartrain Boulevard is the communal tomb of the Army of Tennessee, Louisiana Division. Interred within is Confederate General Pierre G.T. Beauregard (1818–1893). Other Confederate generals interred at Metairie are John Bell Hood (1831–1879) and Richard Taylor (1826–1879), brother-in-law of Jefferson Davis and son of President Zachary Taylor.

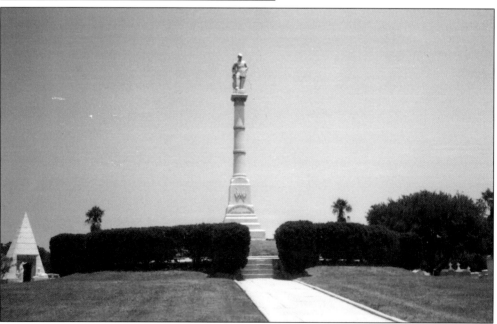

In the center of the westernmost circle of Metairie Cemetery is the 38-foot granite column marking the tomb of the Army of Northern Virginia. When Confederate President Jefferson Davis died at 1134 First Street on December 6, 1889, at the age of 81, he was laid to rest in this tomb. Davis's funeral was the largest in New Orleans history, with 140,000 people paying their respects to the late hero of the South.

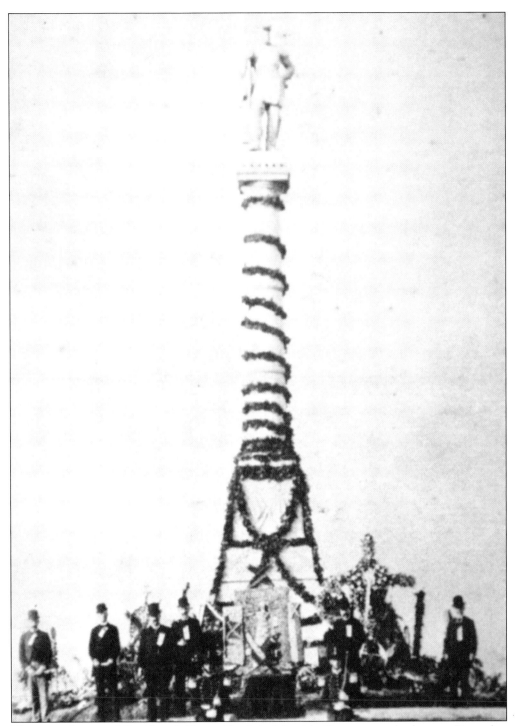

The entombment of President Jefferson Davis in Metairie Cemetery took place on December 11, 1889. On May 31, 1893, Davis's remains were removed from this tomb and shipped to Richmond, Virginia, for re-burial in Hollywood Cemetery. The crypt once occupied by Davis at Metairie still bears his name and the dates of his birth and death, however.

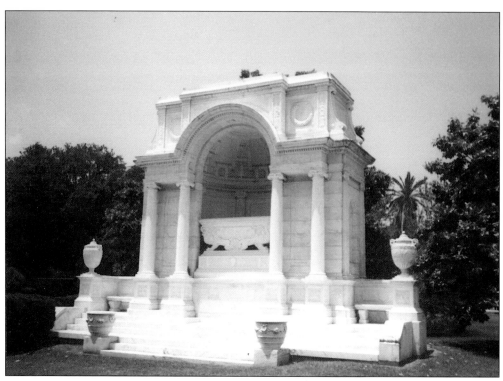

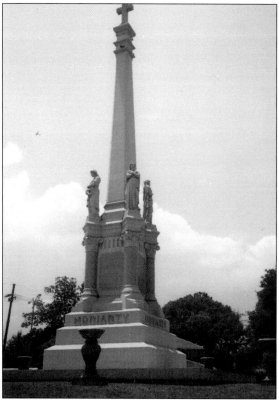

The tomb of Eugene Lacosst (1854–1915), a successful Bourbon Street hairdresser and stock speculator, is a stunning monument of white Alabama marble. Designed by architects Burton & Bendernagel, it was built by stonemason Albert Weiblen.

The 60-foot-high Moriarty monument, the largest monument at Metairie, is clearly visible above the cemetery's forest-like growth of trees from the Pontchartrain Expressway. In 1914 grocer and real estate speculator Daniel Moriarty built the monument as a memorial to his wife, Mary Farrell Moriarty (d. 1887). It was made of stones so heavy that a special railroad spur to the cemetery lot had to be built to haul them in.

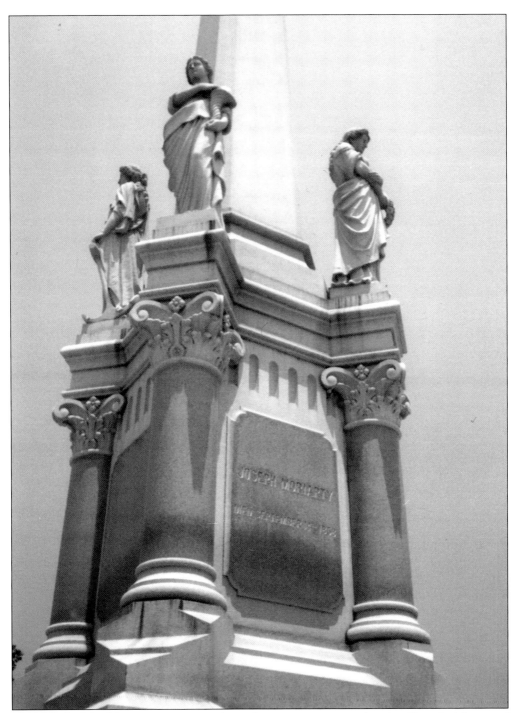

This detail of the Moriarty monument shows four statues representing the allegorical figures of Faith, Hope, Charity, and Memories. Tour guides like to say that the fourth statue represents Mrs. Moriarty, but this is not so. Daniel Moriarty, 22 years his wife's junior, died in 1924 in California and was returned to New Orleans for burial at the foot of the gigantic memorial to his wife.

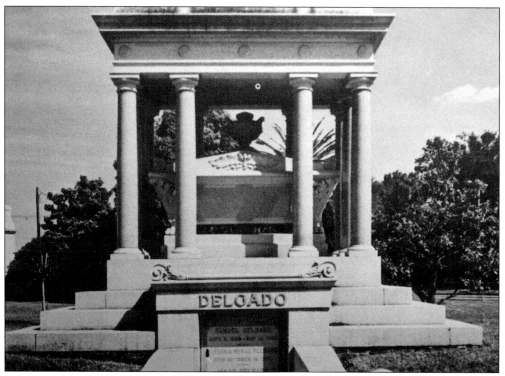

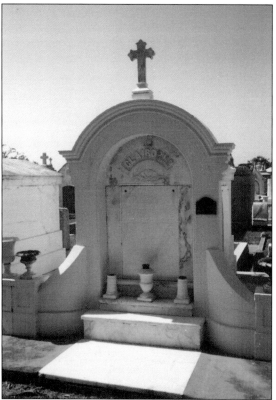

The granite tomb of the Delgado family was built in 1905 by Albert Weiblen. The Delgados were sugar planters of Sephardic Jewish origin and were major benefactors of the New Orleans Museum of Art, the main building of which is named for Isaac Delgado, along with the Central Trade School (now Delgado Community College), and Charity Hospital.

William C.C. Claiborne (1775–1817), the first American governor of Louisiana, was initially interred at St. Louis I but his remains were moved with great fanfare to Metairie in 1880. A Tennessee Supreme Court Justice at the age of 21, and a congressman at age 23, he was governor of Mississippi in 1801 and of Louisiana in 1812. He was elected a senator shortly before his death at the age of 42.

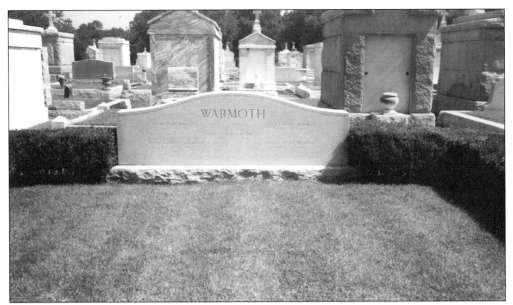

Other governors buried at Metairie include Henry Clay Warmoth (1842–1931), above, and Pickney Benton Stewart Pinchback (1837–1921), below, both of whom served during the tumultuous period of Reconstruction. Though Pinchback was three-quarters white, he is still considered to have been Louisiana's first black governor. Governors Hahn, Heard, Parker, Leche, and both McEnerys are also interred at Metairie.

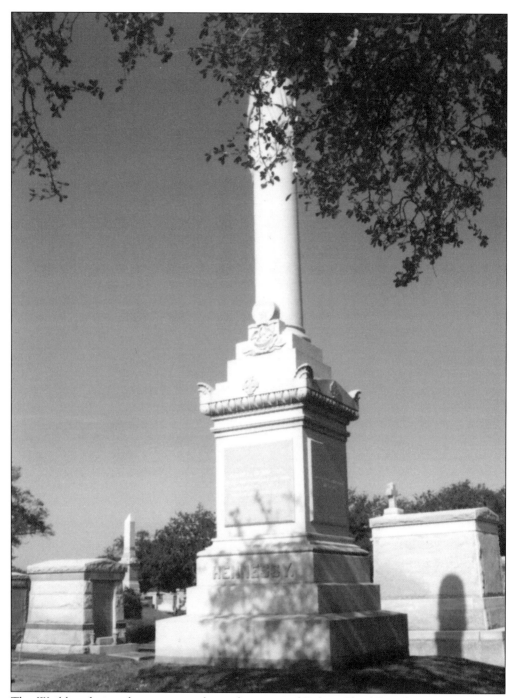

The Weiblen-designed monument above the grave of Police Chief David Hennessy (1858–1890) memorializes the first law enforcement officer in America to be killed by the Mafia. Hennessy was gunned down on October 15, 1890, near his home on Girod Street, off Basin (now Loyola Avenue). He had recently led a crackdown on the growing Mob activity in New Orleans. This monument to him was unveiled in 1893 and bears the star and crescent badge of the New Orleans Police Department.

The gravestone of deLesseps Story Morrison (1912–1964), mayor of New Orleans from 1946 to 1961, was one of the last major designs of Albert Weiblen (who died in 1967 at the age of 99). Morrison, who had run unsuccessfully for governor against Earl K. Long several years earlier, was killed in a plane crash in Mexico at the age of 52. His wife, Corinne (1921–1959), and son John (1956–1964) rest here also. Mayor Robert Maestri rests at Metairie as well.

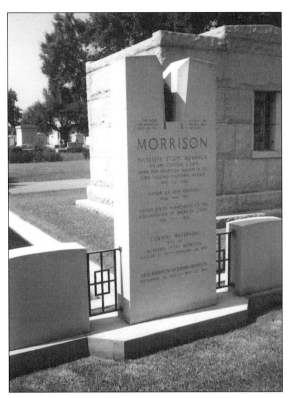

The graves of the Godchaux family, who owned the department store Godchaux's (long a New Orleans institution), are located in the first Jewish section of Metairie. Nearby are the graves of the philanthropic Stern family (Mrs. Stern was the daughter of Sears-Roebuck president Julius Rosenwald) and other prominent merchant families of New Orleans.

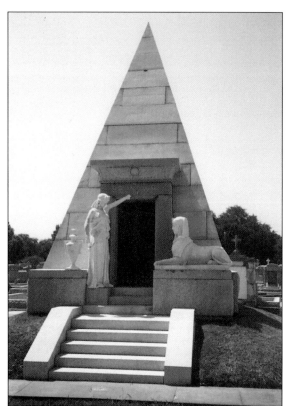

The outstanding Egyptian Revival Brunswig tomb was built for wholesale drug merchant Lucian Brunswig (d. 1892) by Albert Weiblen and is based on the design of a tomb in Brunswig's native Munich, Germany.

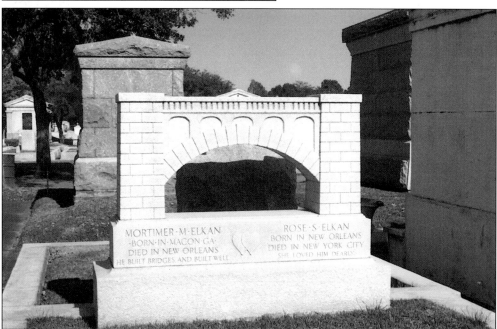

The grave of engineer Mortimer M. Elkan, a native of Macon, Georgia, stands in the first Jewish section of Metairie. Shaped like a stone bridge, it bears the epitaph "He built bridges and built well."

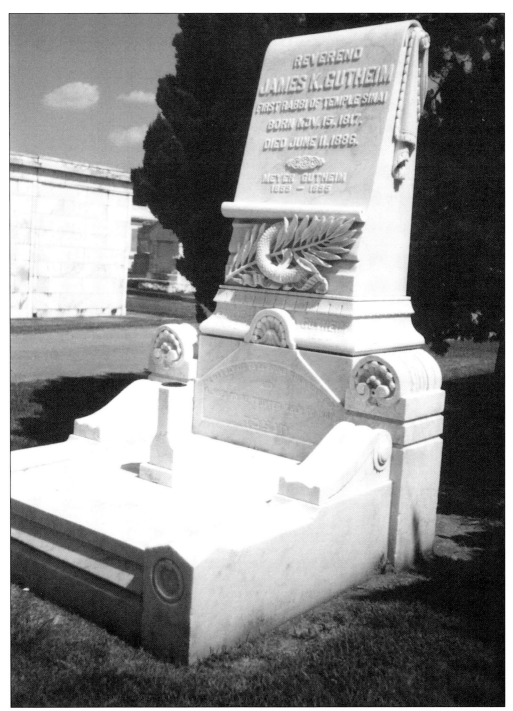

The Weiblen-designed monument of Rabbi James Koppel Gutheim (1817–1886), first rabbi of the Reform Temple Sinai, is located in the first Jewish section. One of the most influential Reform rabbis in 19th-century America, Gutheim's funeral was the largest in New Orleans history save that of Jefferson Davis.

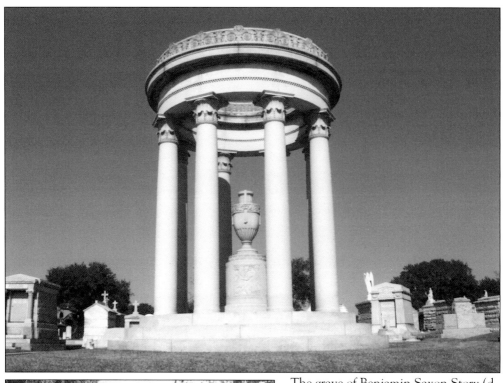

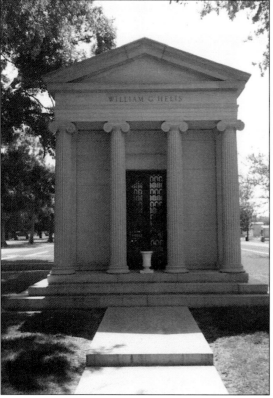

The grave of Benjamin Saxon Story (d. 1901) was also designed by Weiblen and imitates a circular Roman temple. Story was a prominent planter, civic leader, and veteran of the Civil War.

The tomb of oilman William G. Helis was designed by Ralph Phillippi and is modeled on the temple of Nike at the Acropolis in Athens, Greece. Inside, Mr. Helis's sarcophagus rests on soil imported from Greece, his native land.

The Celtic cross marking the graves of the Palfry-Rogers-Brewster family is intricately carved with religious symbols including the dove (Holy Spirit), Eucharistic cup, menorah, pelican (self-sacrifice), the True Vine, and the interlaced Chi Rho (symbolic of the name of Christ). It stands 15 feet high and was designed by Weiblen.

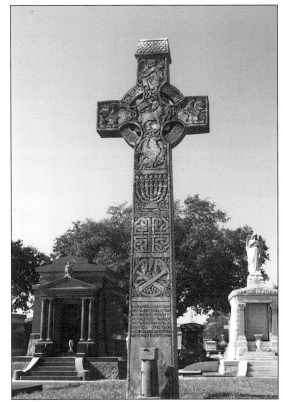

The monument of newspaper owner Edith Allen Clark is a large polished black granite block to which is affixed a cast bronze Pieta by sculptor Felix de Weldon, creator of the well-known Iwo Jima monument in Washington, D.C. It was built in the 1960s.

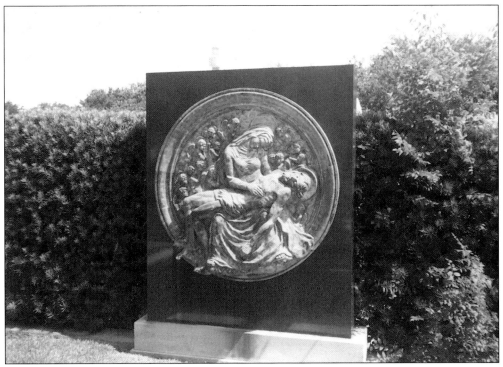

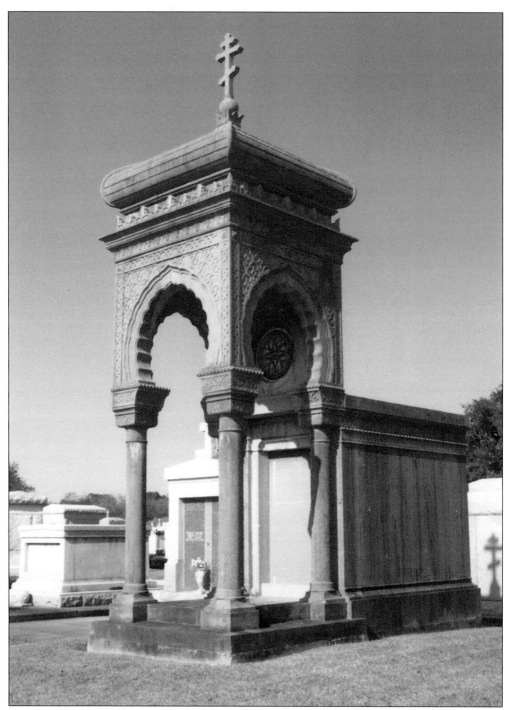

The splendid Moorish Revival Larendon tomb was built in 1885 by General P.G.T. Beauregard for his daughter, Laure Beauregard Larendon. The material is Belgian limestone, and the tomb is believed to have been built in Europe and shipped in pieces to New Orleans. Charles Larendon, Laure's husband, died in 1888. A small model ship was once suspended between the arches but it has long since vanished.

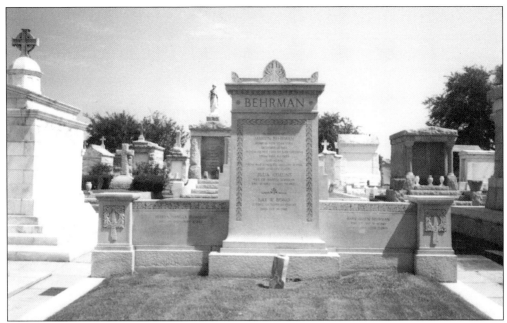

Mayor Martin Behrman (1864–1926) led the Crescent City from 1904 to 1920 and from 1925 until his death in January 1926. Made of granite from Stone Mountain, Georgia, Behrman's monument (above) was designed and built by Albert Weiblen. The Gumbel monument (below) is located in the first Jewish section. Philanthropist Sophie Gumbel (1844–1918) endowed the Gumbel Home for Girls and donated the fountain at the entrance to Audubon Park.

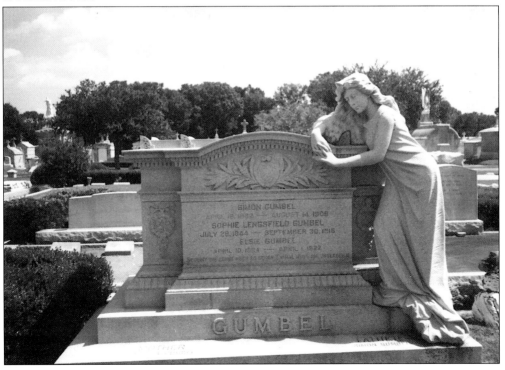

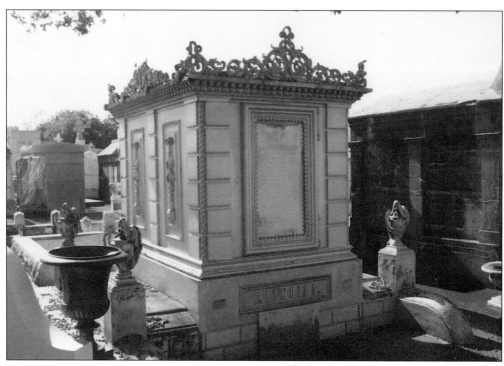

The Reynolds tomb is of cast iron, unusual for Metairie Cemetery, and was made at the Reynolds foundry in New Orleans. The tomb, which dates from 1877, is one of the earlier monuments at Metairie Cemetery.

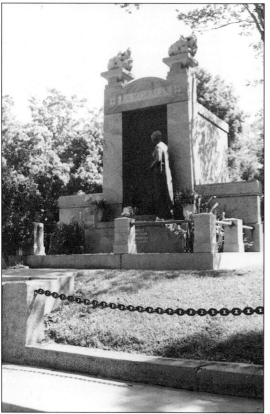

The polished red Maine granite tomb built in 1911 by Albert Weiblen for successful Storyville madam Josie Arlington (1864–1914), whose real name was Mary Anna "Mamie" Deubler, attracted so many curious visitors that Arlington's relatives had Madam Josie's remains moved to an unmarked crypt elsewhere in the cemetery (its location is a closely guarded secret) and the tomb was sold to the Morales family.

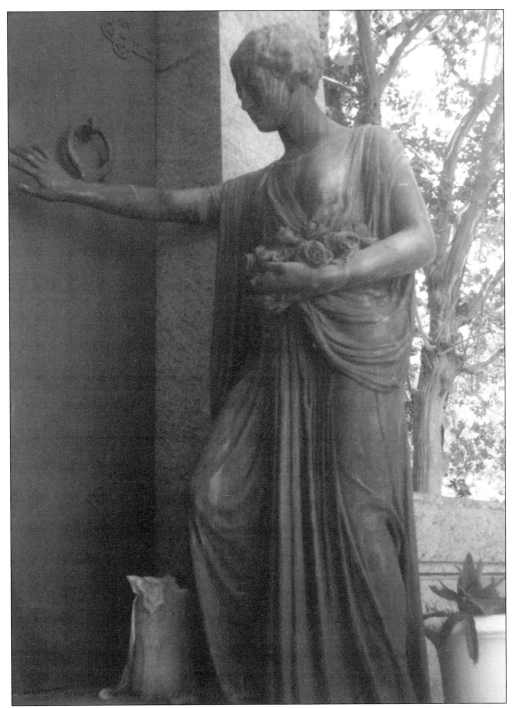

The bronze statue at the entrance to the Josie Arlington tomb was created by sculptor F. Bagdon. It represents, curiously enough, the faithful virgin (not Josie being rebuffed at her father's door as some local legends say). Also interred at Metairie is Storyville boss Tom Anderson (1861–1931), a one-time "business partner" with Josie. He rests with his wife, former Storyville madam Gertrude Dix (1874–1961).

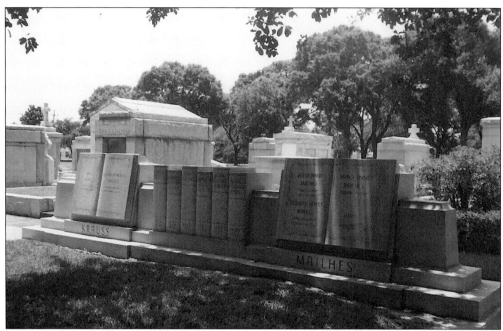

The Krauss-Mailhes monument (above) in the new section of Metairie Cemetery was designed by Phillippi and Weiblen and is built of granite. The monument imitates a bookshelf with two open books representing younger members of the family and six closed books between, representing the older members. Taller books represent husbands, shorter represent wives. The c. 1930 Fabacher tomb (below) was designed by Weiblen for the family of Lawrence Fabacher, who owned the Jackson Brewing Company, makers of Jax Beer.

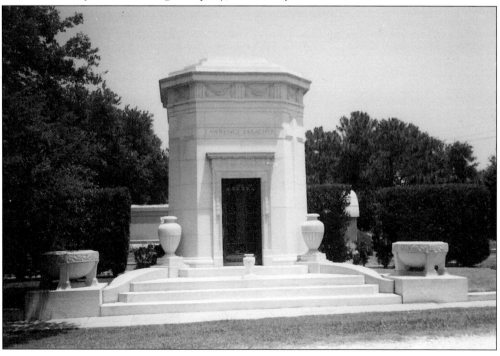

The Edward Bobet family tomb, dating from the 1920s, was designed by Charles Lawhon and carved by Charles Dodd. Weiblen erected the structure itself. The Bobet tomb is unique in its incorporation of the cross as an architectural feature of the primary elevation, as opposed to an ornamental or symbolic feature.

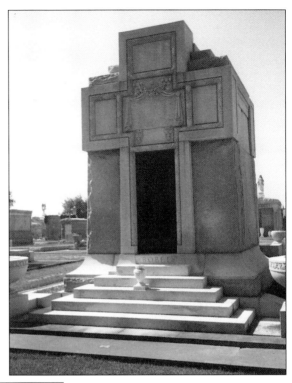

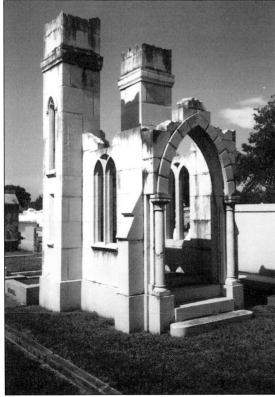

The equally unique monument of the Henry I. Egan family (1881) is a Gothic Revival sham ruin. Pains were taken to imitate the effects of broken, cracked, and crumbling stone. It was designed and built by Charles A. Orleans.

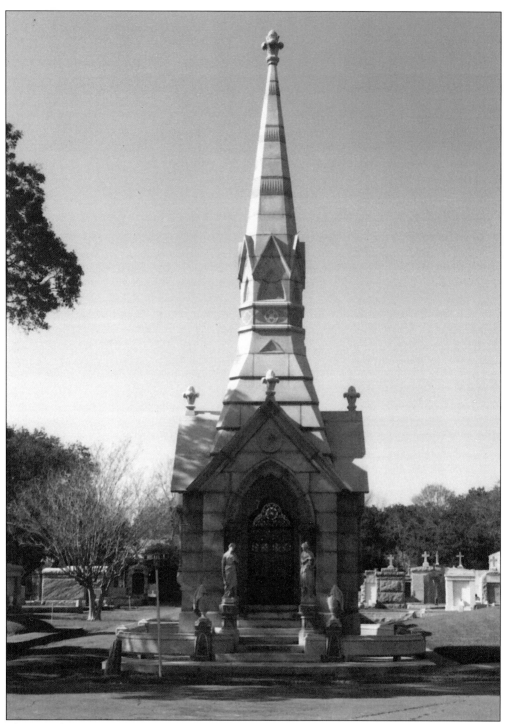

The David McCann tomb, built around 1900, probably by Charles A. Orleans, is the tallest tomb in Metairie Cemetery (the Moriarty monument and several others are taller, but they are grave markers, not tombs). Several other important Gothic Revival tombs from the same era stand nearby.

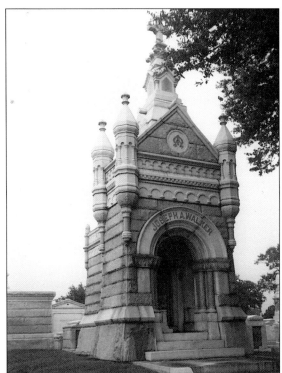

The eclectic Romanesque tomb of Joseph A. Walker (1893), at right, is believed to have been designed by Charles Orleans. The similar though more Baroque tomb of fruit importer Capt. Salvatore Pizzati (below), whose favorite rocking chair is entombed with its owner inside, is by architect Theodore Brune.

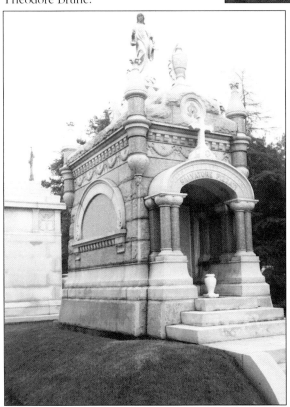

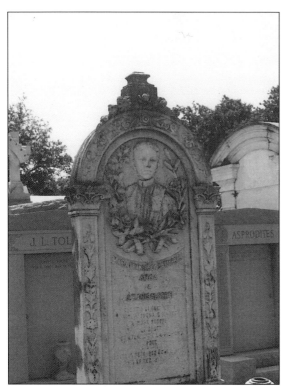

The gravestone of Maria Francesca Saltarelli Ghisalberti (1851–1892) bears a lifelike portrait of the deceased. The epitaph is entirely in Italian. Many Italian and Sicilian immigrants arrived in New Orleans during the 19th century, and today the city has one of the nation's largest Italian-American communities.

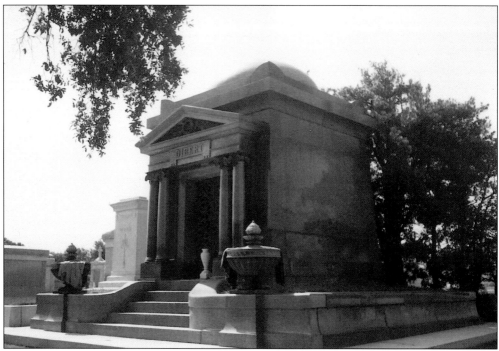

The Dibert family tomb (1912) is a striking domed Neo-Classical design, built by Albert Weiblen and ornamented with heavy bronze doors and urns. The philanthropic Diberts, who were foundry owners, substantially endowed Charity Hospital.

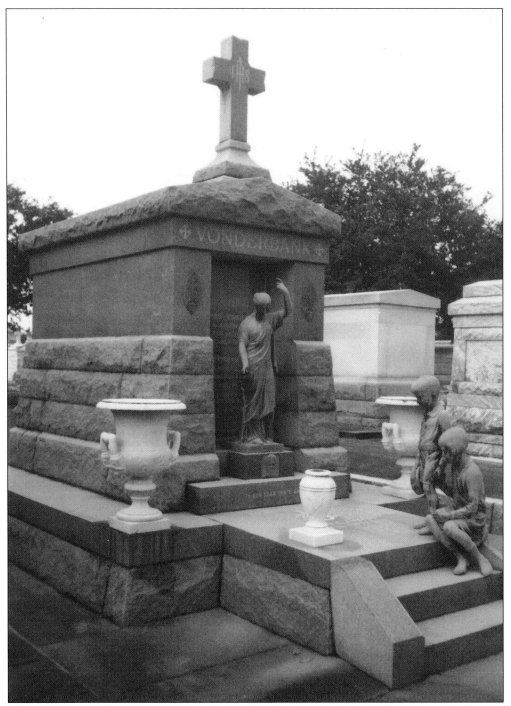

The Babette Vonderbank Ahrens tomb (1929), of red Missouri granite, features three bronze statues; one, representing Memories, stands at the door beckoning the others, two children. The children are life-size representations of Mrs. Ahrens's niece and nephew, who hold hands and look contemplatively at a small relief portrait of their aunt, just beneath the statue of Memories. The sculptures are by Albert Rieker of New Orleans.

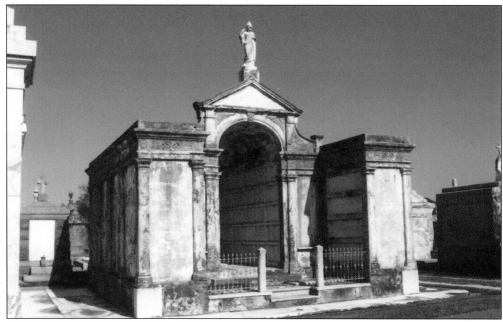

As with other historic cemeteries of New Orleans, Metairie possesses numerous society tombs, two of which are pictured on this page. The Minerva Benevolent Association tomb (1879) is shown above. The Contessa Entillina Association tomb (1886), below, is the largest capacity tomb in the cemetery. Metairie, which was listed on the National Register of Historic Places in 1991, possesses literally thousands of fascinating tombs, and a visit to the cemetery can fill a day, or even several.

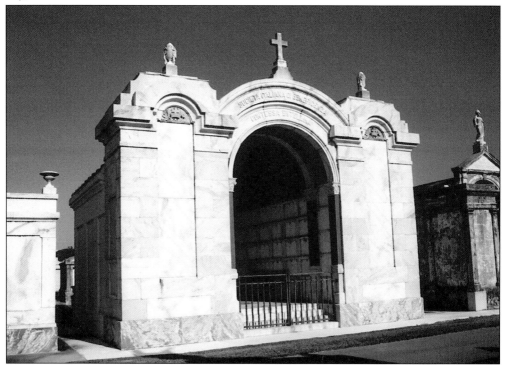

Nine

GIROD STREET:
THE LOST CEMETERY

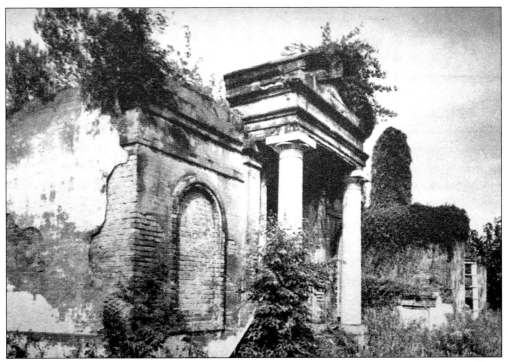

The Girod Street Cemetery was founded in 1822 by Christ Church, Episcopal (now Christ Church Cathedral). It was a narrow but deep cemetery, three aisles wide and bounded by wall vaults. There were 2,845 "oven" vaults, 100 society tombs, and approximately 1,000 family tombs ultimately erected at Girod. The largest and finest of the society tombs was that of the New Lusitanos Benevolent Association, designed by J.N.B. de Pouilly and dedicated in 1859. As with the rest of the cemetery, the New Lusitanos tomb was allowed to deteriorate, and by the time this photograph was made in 1954 it was virtually a ruin. In 1957 the Girod Street Cemetery was deconsecrated and entirely demolished.

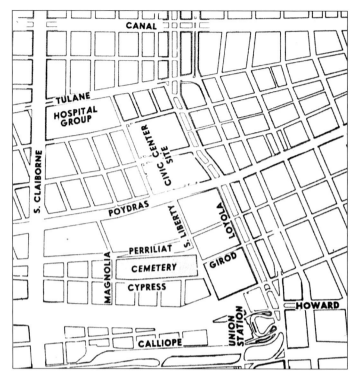

This map shows the former location of the Girod Street Cemetery. The Poydras Plaza Shopping Mall and the main post office stand on the lower portion of the cemetery site, and part of the Superdome stands on the upper portion (it is said that the Saints have a difficult time scoring in the endzone marked "Girod"). The deterioration and loss of this landmark is a disgraceful chapter in the city's history.

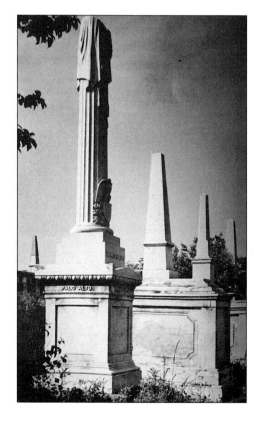

The monument of Colonel William Wallace Smith Bliss (1815–1853) stood over his grave at Girod Street until 1955, when the U.S. Army moved the grave and monument to Ft. Bliss, Texas, where it is located today. Colonel Bliss, a hero of the Mexican War, was the brother-in-law of both Jefferson Davis and General Richard Taylor and a son-in-law of President Zachary Taylor.

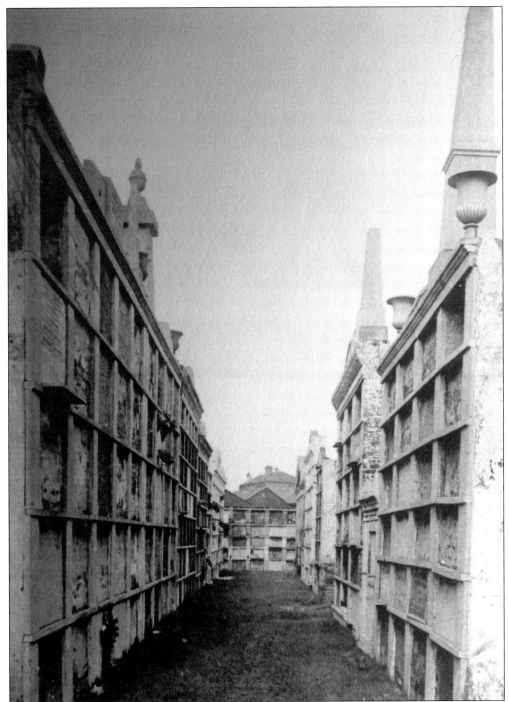

This photograph of one of the cemetery's aisles was taken about 1895. Many prominent citizens were interred at Girod Street, including a number of prominent clergymen, newspaper editors, and businessmen; writer Irwin Russell (1853–1879); president of the Bank of Louisiana Benjamin Story (1783–1847); and Ellen Galt Martin (1826–1849), who was the lover of adventurer (and briefly dictator of Nicaragua) William Walker.

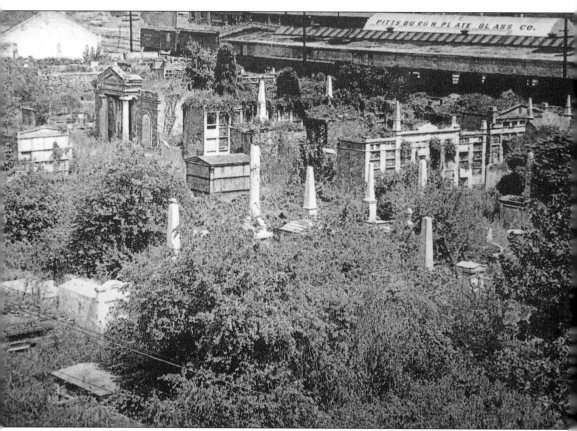

Girod Street Cemetery is shown here in the 1940s. The New Lusitanos Society tomb is prominent in the upper left quadrant. Just below and to its right (almost in the center of the photograph) is the tomb of Benjamin Story, in front of which is the tall column of Colonel Bliss. The large cluster of society tombs at right center were built by several pre-Civil War black benevolent associations, which included among their members both free blacks and slaves.

The remarkable obelisk of the Dow family, with its skull and crossbones motif, was one of the first placed at Girod Street in 1822. It was a memorial to Angelica Dow, wife of Dr. Robert Dow, a prominent physician and co-founder of Christ Church in 1805. Angelica was Jewish and Robert Episcopalian.

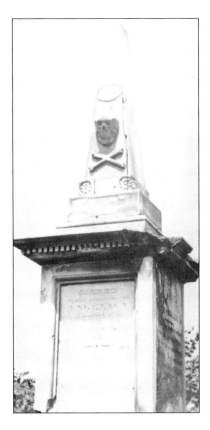

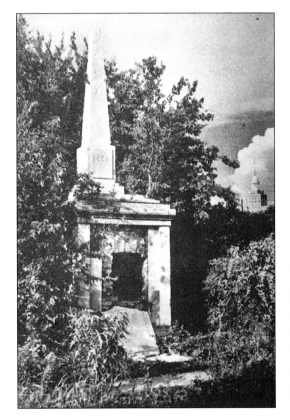

This broken tomb, dated 1858, once stood in a row of similar tombs located near the Bliss monument at the cemetery's center. By the 1950s many families had removed their ancestors' remains to other cemeteries, sometimes leaving the old tombs open. Other tombs were opened by vandals and grave robbers. In the distance at right is the Hibernia National Bank Building.

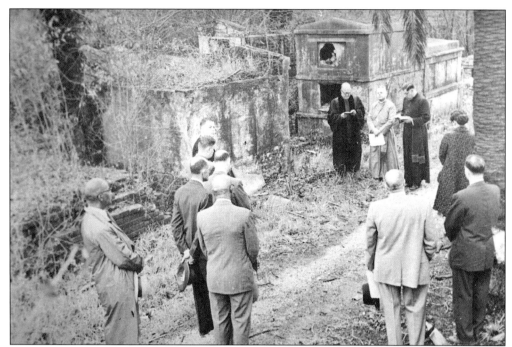

The deconsecration of the Girod Street Cemetery took place on January 4, 1957; demolition began shortly thereafter and took some nine months to complete. An estimated 3 million bricks were removed from the cemetery, and a number of outstanding monuments and vault slabs were salvaged and are preserved in the Louisiana State Museum.

While many families moved their relatives' remains to other cemeteries, the majority of Girod Street interments were relocated en masse to Hope Mausoleum, built beginning in 1931 around the perimeters of St. John Cemetery (founded in 1867) on Canal and North Bernadotte Streets. The majority rest beneath the stairwell shown here.

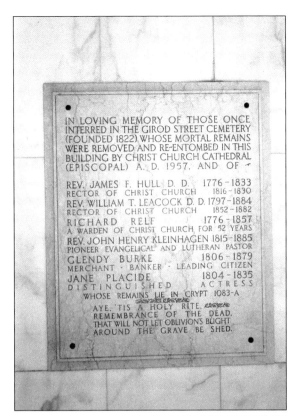

Two crypt tablets in Hope Mausoleum commemorate the re-interments of prominent New Orleanians within. Other mass re-interments, primarily of the occupants of the black society tombs, took place at Providence Memorial Park, located at 8200 Airline Highway in Metairie.

IN LOVING MEMORY OF THOSE ONCE INTERRED IN THE GIROD STREET CEMETERY (FOUNDED 1822) WHOSE MORTAL REMAINS WERE REMOVED AND RE-ENTOMBED IN THIS BUILDING BY CHRIST CHURCH CATHEDRAL (EPISCOPAL) A. D. 1957. AND OF

REV. JAMES F. HULL D. D. 1776 - 1833
RECTOR OF CHRIST CHURCH 1816 - 1830
REV. WILLIAM T. LEACOCK D. D. 1797 - 1884
RECTOR OF CHRIST CHURCH 1852 - 1882
RICHARD RELF 1776 - 1857
A WARDEN OF CHRIST CHURCH FOR 52 YEARS
REV. JOHN HENRY KLEINHAGEN 1815 - 1885
PIONEER EVANGELICAL AND LUTHERAN PASTOR
GLENDY BURKE 1806 - 1879
MERCHANT · BANKER · LEADING CITIZEN
JANE PLACIDE 1804 - 1835
DISTINGUISHED ACTRESS
WHOSE REMAINS LIE IN CRYPT 1083-A

AYE, 'TIS A HOLY RITE.
REMEMBRANCE OF THE DEAD,
THAT WILL NOT LET OBLIVION'S BLIGHT
AROUND THE GRAVE BE SHED.

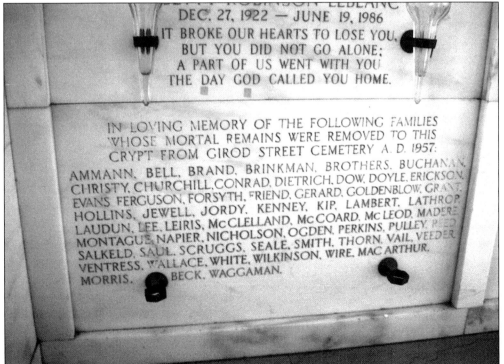

DEC. 27, 1922 — JUNE 19, 1986
IT BROKE OUR HEARTS TO LOSE YOU,
BUT YOU DID NOT GO ALONE;
A PART OF US WENT WITH YOU
THE DAY GOD CALLED YOU HOME.

IN LOVING MEMORY OF THE FOLLOWING FAMILIES
WHOSE MORTAL REMAINS WERE REMOVED TO THIS
CRYPT FROM GIROD STREET CEMETERY A. D. 1957:
AMMANN, BELL, BRAND, BRINKMAN, BROTHERS, BUCHANAN,
CHRISTY, CHURCHILL, CONRAD, DIETRICH, DOW, DOYLE, ERICKSON,
EVANS FERGUSON, FORSYTH, FRIEND, GERARD, GOLDENBLOW, GRANT,
HOLLINS, JEWELL, JORDY, KENNEY, KIP, LAMBERT, LATHROP,
LAUDUN, LEE, LEIRIS, McCLELLAND, McCOARD, McLEOD, MADERE,
MONTAGUE, NAPIER, NICHOLSON, OGDEN, PERKINS, PULLEY, REED,
SALKELD, SAUL, SCRUGGS, SEALE, SMITH, THORN, VAIL, VEEDER,
VENTRESS, WALLACE, WHITE, WILKINSON, WIRE, MAC ARTHUR,
MORRIS, BECK, WAGGAMAN.

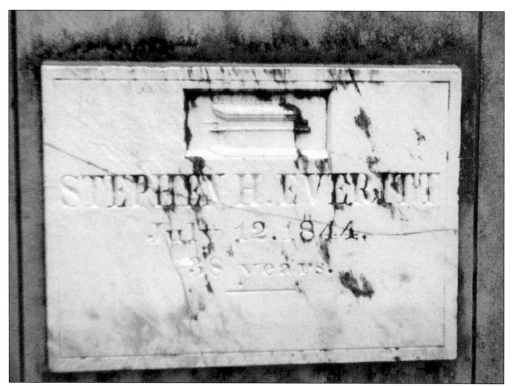

A number of vault tablets from the Girod Street Cemetery are today affixed to the walls of Hope Mausoleum facing St. John Cemetery. Above is the marker of Stephen H. Everitt (1807–1844), signer of the Texas Declaration of Independence and president of the Senate of the Republic of Texas. Below is the marker of Thomas Montague (1833–1866), pilot of the steamboat *Fashion*, who lost his life but saved the majority of his passengers by running the burning boat ashore.

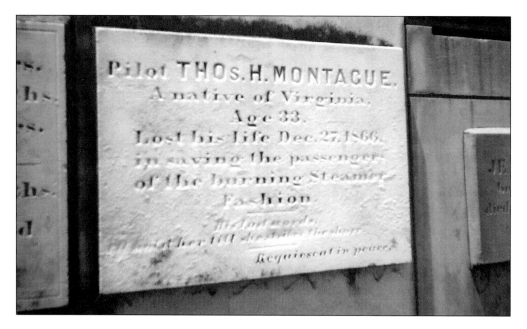

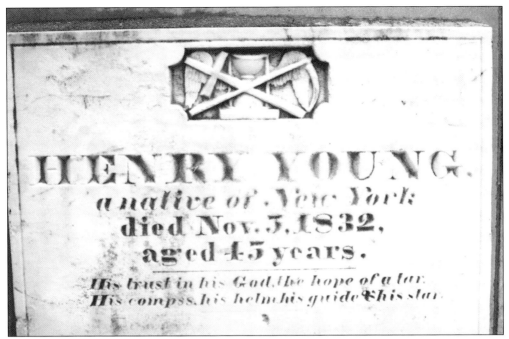

HENRY YOUNG.
a native of New York
died Nov. 5, 1832,
aged 45 years.

His trust in his God, the hope of a tar.
His compss, his helm, his guide, this star.

Above is the preserved vault slab of Henry Young (1787–1832), proprietor of the Mariner's Coffee Shop, established in 1824. The marker, carved by Horace Blakesley, one-time sexton of Girod Street Cemetery, bears the "tempus fugit" motif of the winged hourglass. A group of Girod Street Cemetery vault tablets are shown below as they appear today.

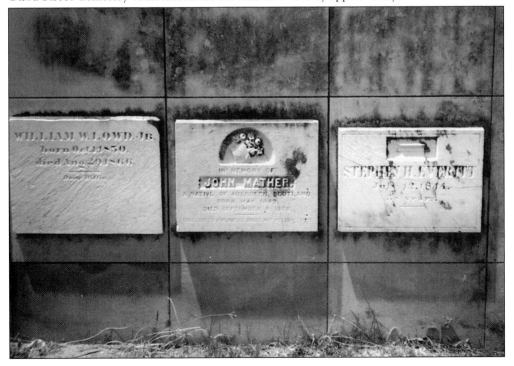

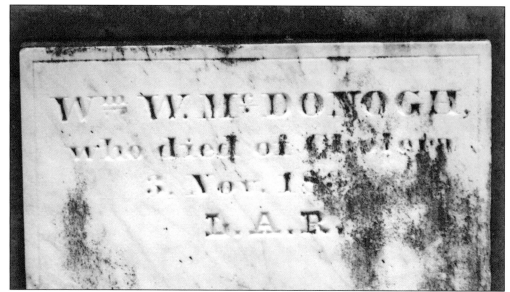

William McDonogh (1797–1832) was the younger brother of noted philanthropist John McDonogh, who so generously endowed the city's public school system as to have virtually created it. Many New Orleans public schools still bear the name McDonogh today. William died of cholera and was buried at Girod Street; John was first interred in the suburb of Gretna but was later moved to his native Baltimore, Maryland, where he rests today.

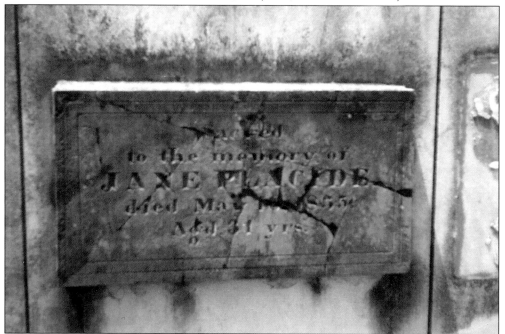

This is the marker of actress Jane Placide (1804–1835). Another tablet on her tomb bore the epitaph "There's not an hour of day or dreaming night but I am with thee; There's not a wind but whispers of thy name, and not a flower that sleeps beneath the moon but in its hues or fragrance tells a tale of thee." The epitaph was placed by theater manager James Caldwell, with whom she was romantically involved. Caldwell (1793–1863) rests at Cypress Grove Cemetery.

Ten

OTHER HISTORIC
BURIAL GROUNDS
OF NEW ORLEANS

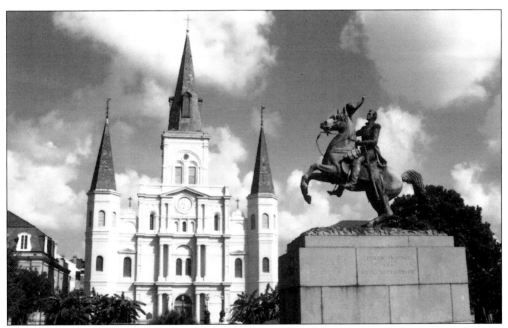

The Basilica of St. Louis contains, like many great churches, numerous graves. The church's site was chosen in 1721 and its plan drawn by Sieur Adrian de Pauger. The first church was dedicated in 1727 and was rebuilt in 1794. The present facade is by J.N.B. de Pouilly and dates from 1849. The oldest recorded burial in the church is that of a Monsieur Alias (d. 1721), Royal Director of the Law Concessions. De Pauger, who laid out the French Quarter, was buried there in 1726. Governor Gayoso de Lemos (1751–1799) and prominent Don Andres Almonester y Roxas (1724–1798), who rebuilt the church in 1794, rest here as well. The view above is from Jackson Square, the Place d'Armes of the French Quarter. The famous statue of Andrew Jackson by Clark Mills (1856) is at right.

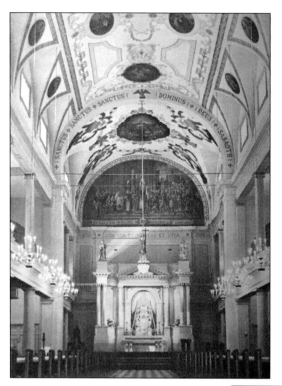

This is the interior of the Basilica of St. Louis. At least 11 burials here predate 1753, and 47 are known to have taken place since 1793. The exact number of interments inside the Cathedral is uncertain, however. Burial records are housed in the Cathedral archives at the Basilica, which was made a National Historic Landmark in 1960.

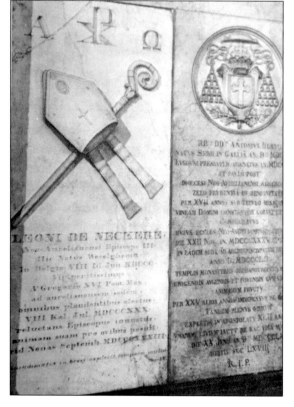

Two of the numerous memorial tablets found inside the Basilica of St. Louis are shown here. The one at left is of Bishop Leon de Neckere (1800–1833); that at right is of Archbishop Antoine Blanc (1792–1860). Seven other archbishops are also buried in the Basilica, as are several rectors of the church and other religious persons.

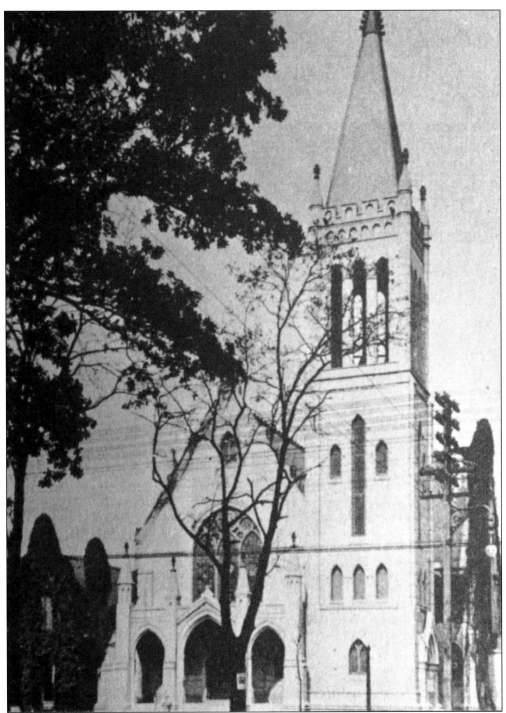

Another church containing significant burials is the Episcopalian Christ Church Cathedral at 2919 St. Charles Avenue. Among those buried within is Confederate General and Episcopal Bishop Leonidas Polk (1806–1864), who fell at Pine Mountain, Georgia. The church is seen here as it appeared prior to the Hurricane of 1915, which toppled its spire (it was never rebuilt).

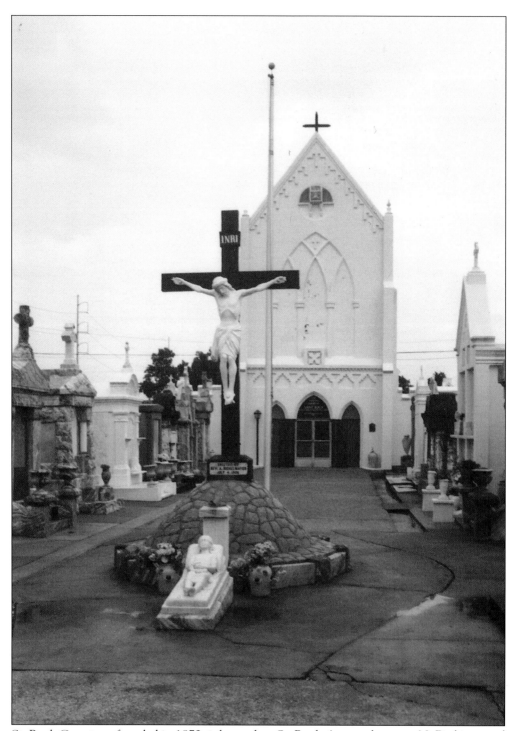

St. Roch Cemetery, founded in 1872, is located on St. Roch Avenue between N. Derbigny and N. Roman Streets. It was established by Rev. Peter Thevis, after his congregation was spared of any deaths during the yellow fever epidemic of 1867, a miracle he attributed to St. Roch's intercession. The chapel was completed in 1874.

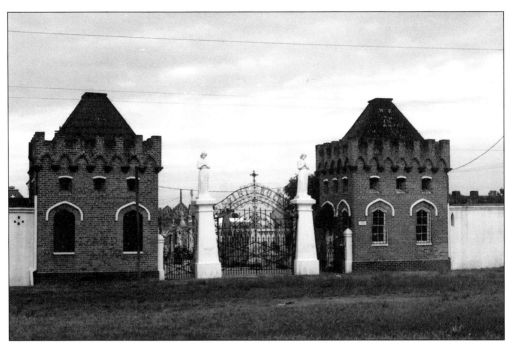

The main gates of St. Roch Cemetery are an eclectic blending of Gothic Revival structures with Egyptian Revival pylon gate posts crowned by statues. The cemetery's walls are filled with "oven" vaults for multiple interments.

The well-known marble carving of the sick girl who was healed represents the miracles attributed to St. Roch. Hundreds of pilgrims came to the chapel to leave offerings behind, including crutches, braces, and models of limbs they credit St. Roch's intercession with healing. Many came to pray for a spouse as well.

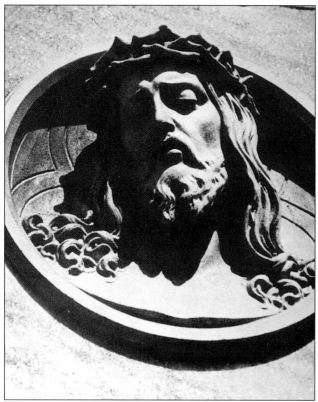

Just behind St. Roch Cemetery is the Campo Santo, or St. Roch Cemetery Number II. It had fallen into a dismal state of disrepair by the 1920s but was afterwards restored and is today in immaculate condition. The main aisle of the cemetery is seen here through the Music Street gates.

The three St. Patrick Cemeteries were begun by the Irish Catholic community in 1841. St. Patrick I and II lie on opposite sides of Canal Street, a short distance south of City Park Avenue. St. Patrick III lies across City Park Boulevard. The densely packed cemeteries contain some lovely carvings, such as this relief portrait of Jesus from the late 19th century.

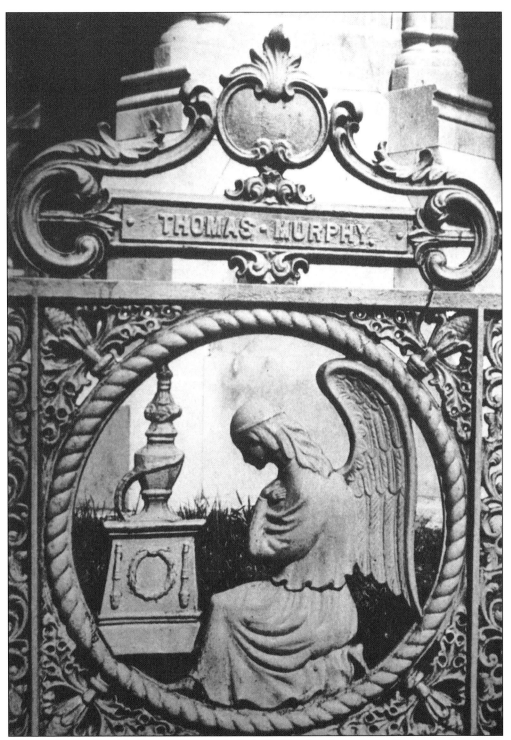

Also in the St. Patrick Cemeteries, particularly in Number I, are some fine examples of cast iron, such as this gate depicting an angel at a tomb. The gate guards the Thomas Murphy family lot (1850s). The majority of burials at the St. Patrick Cemeteries are in-ground.

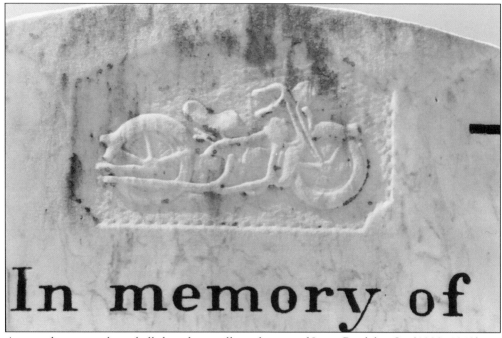

A carved motorcycle embellishes the small tombstone of Leon Bordelon Jr. (1920–1942), an employee of the Delta Shipyard. His co-workers erected the monument, which is located near the Banks Street entrance to St. Patrick II.

Next to St. Patrick I is Odd Fellows Rest Cemetery, founded by the fraternal Independent Order of Odd Fellows in 1849 at the corner of Canal Street and City Park Avenue. The Canal Street gates bear numerous symbols of the society. Odd Fellows Rest was listed in the National Register of Historic Places in 1980.

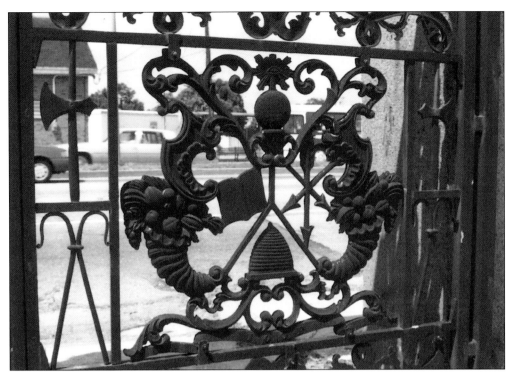

This detail shows one of the panels on the cast-iron gates of Odd Fellows Rest. Depicted are cornucopias (symbolic of plenitude), a beehive (industry), a book (knowledge), and an eye with rays above a globe (the all-seeing eye of God watching over the world). Axes and crossed crooks represent both war and peace and law and order. This panel is one of numerous New Orleans cemetery artifacts stolen in the 1990s. Some items were never recovered; others were found as far away as Los Angeles, New York, and Vermont. The trials of several of those accused in the thefts took place in May 2000, and were extensively covered by the national media.

The Howard Association tomb (1850s) is surmounted by a monument bearing a portrait of the society's founder, Englishman John Howard (1726–1790). The New Orleans Howards formed in 1837 to provide assistance during epidemics, especially yellow fever.

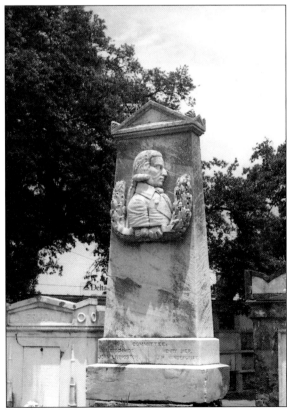

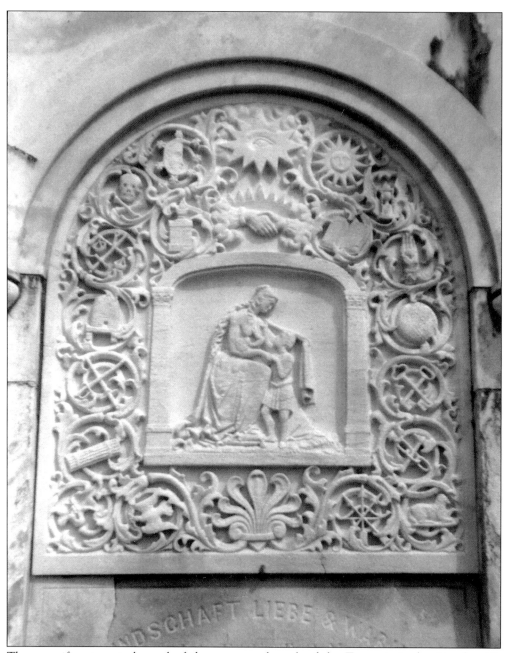

The magnificent central panel of the communal tomb of the Teutonia Lodge Number 10, IOOF, was built in 1851. The tomb is now that of the Southwestern Lodge Number 40. As with the nearby gates to the cemetery, the tomb's panel is rich in symbolism.

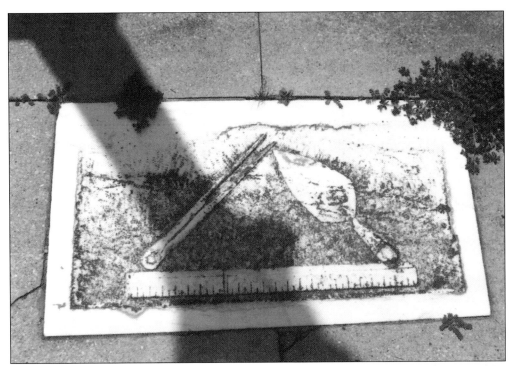

Masonic Cemetery is bounded by City Park Avenue and Bienville, North Anthony, and St. Louis Streets. It was established in 1865, though Freemasonry's first official lodge in New Orleans was founded in 1793. Above is a detail of a step in front of a society tomb. Below is the tomb of the Red River Pilots Association (1869), an alliance of steamboat pilots operating between New Orleans and Shreveport, the state's two principal 19th-century cities.

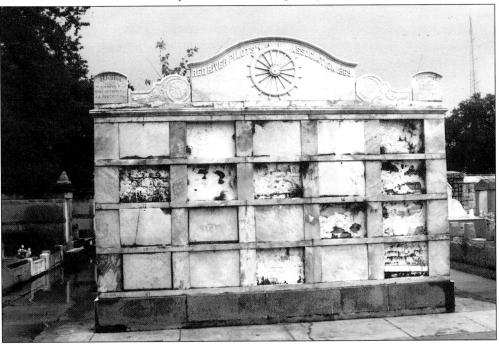

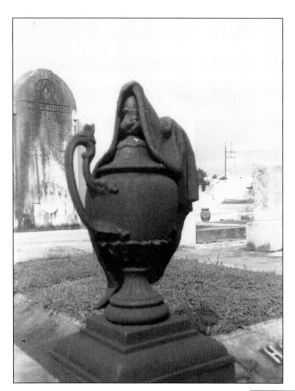

This cast-iron urn is on a corner of the cast-iron coping (the curb surrounding an in-ground burial plot) of the Hotchkiss/Bedford lot at Masonic Cemetery (1876). The use of cast iron for gravesite embellishment is not uncommon but its use for copings is.

The gates of Charity Hospital Cemetery on Canal Street are located just below the entrance to Cypress Grove Cemetery. Although this cemetery contains no tombs and virtually no markers, many thousands of indigent dead are buried here, including victims of cholera and yellow fever epidemics, unidentified dead, prostitutes from Storyville, and other anonymous New Orleanians. The cemetery opened in or just prior to 1847 and remained in use into the 1930s.

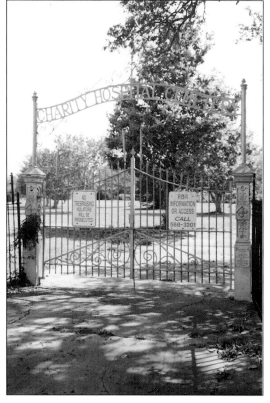

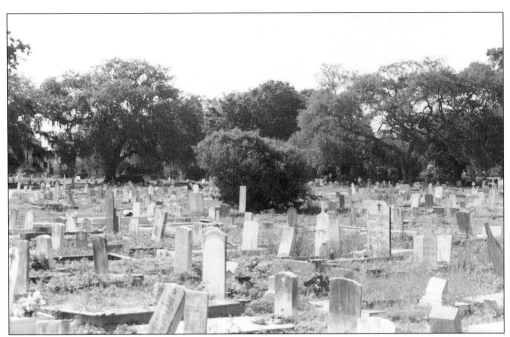

Holt Cemetery is located just off City Park Avenue, behind Delgado Community College. It also has an entrance at the southern end of General Diaz Street. Holt was founded by the city in 1879 as a burial ground for the indigent dead. It is the successor to the now-vanished Locust Grove I and II Cemeteries (1858), located on Freret Street between Sixth and Seventh. Holt contains tens of thousands of graves, all in-ground burials, most several layers deep. Carrollton Cemetery (1849), bounded by Adams, Hickory, Lowerline, and Birch Streets, presents a similar appearance. Perhaps Holt's most famous occupant is Charles "Buddy" Bolden (1868–1931), the famed jazz musician.

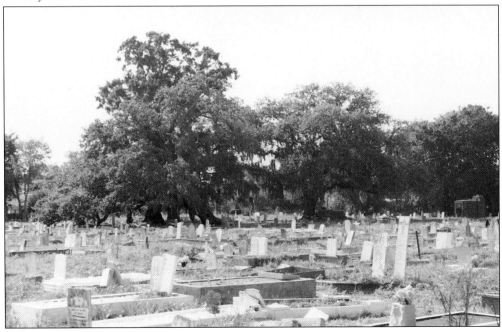

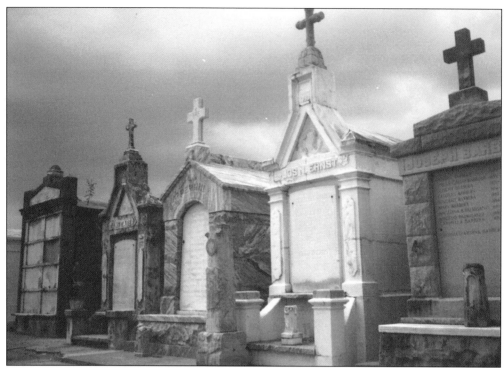

The Valance Street Cemetery in the Uptown section of New Orleans was established about 1850, though the precise date is uncertain. Located at Valence and Saratoga Streets, the cemetery contains several 19th-century society tombs. German-born philanthropist David Fink (d. 1856) was moved here from the Girod Street Cemetery in the 1950s.

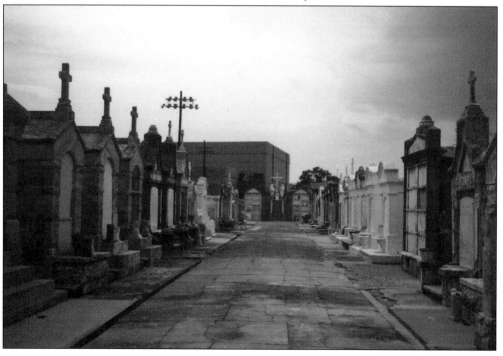

St. Vincent de Paul I, II, and III occupy three squares in the vicinity of N. Villere and Louisa Streets. Established by the Catholic church in 1844, the cemeteries were acquired by Spanish-born duelist Jose "Pepe" Lulla (d. 1888) in 1857. Many buried here are from the city's large 19th-century German community. Also at rest here is General Anthony Sambola, a flamboyant civic leader of the 1850s; Marie, Queen of the Tinka Gypsies (d. 1916); Pedro Abril and Vincente Bayona, two notorious murderers hanged in the 1860s; and Mother Catherine Seals, the famed spiritualist (d. 1930). The intricate brickwork on the Piety Street wall of St. Vincent de Paul III is shown here.

ABOUT THE AUTHOR

Eric J. Brock is a well-known and respected Louisiana historian and writer. He is a member of numerous historical and preservation organizations, including Save Our Cemeteries and the Preservation Resource Center of New Orleans. He has served on the board of the Louisiana Preservation Alliance and is active with the Association for Gravestone Studies, a national cemetery and grave marker research and preservation organization. He resides in Shreveport, Louisiana. This is his third book for Arcadia.